The Luminous Years

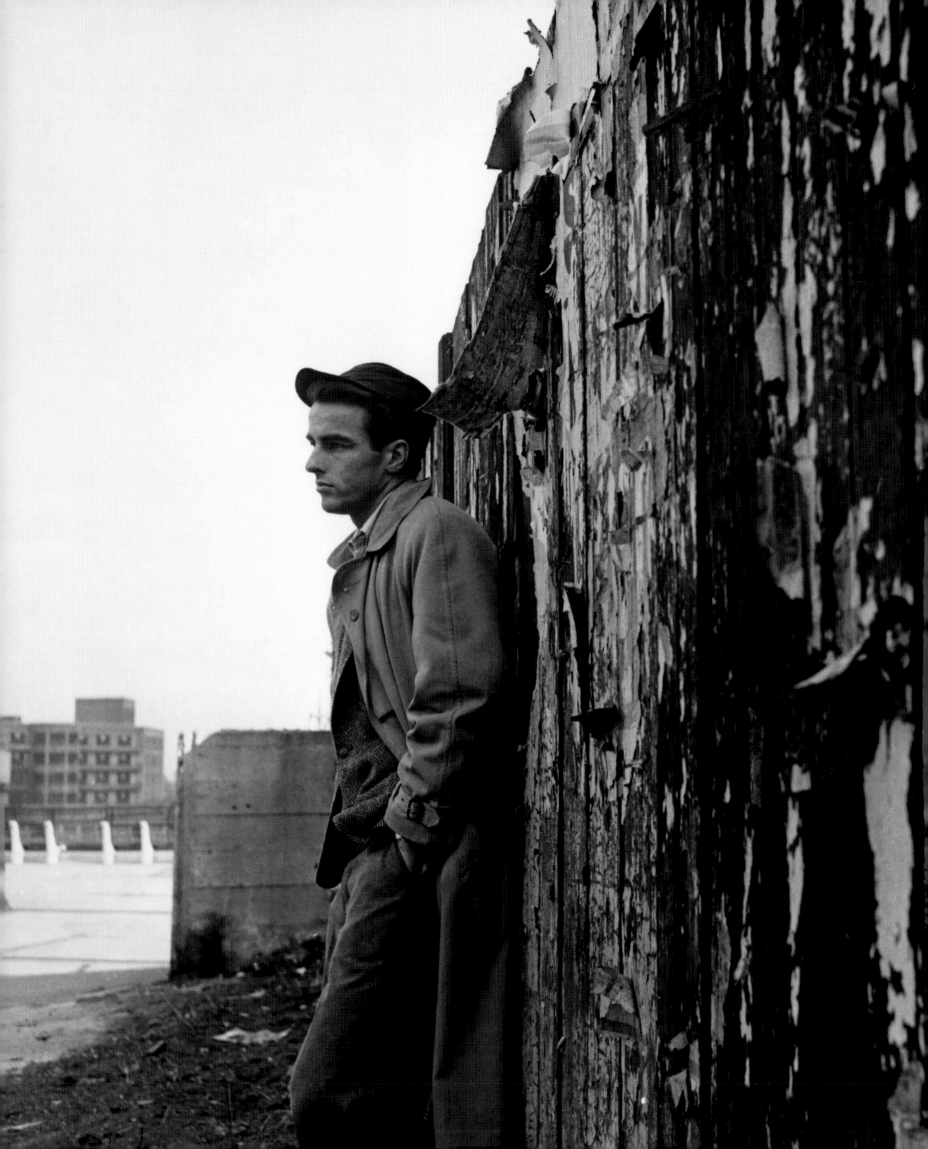

The Luminous Years Portraits at Mid-Century by Karl Bissinger

Introduction by Gore Vidal

Catherine Johnson, Editor

Harry N. Abrams, Inc., Publishers

Frontispiece: Montgomery Clift, New York, 1948

Editor: Christopher Sweet
Designer: Judith Hudson
Production Manager: Jane Searle

Library of Congress Cataloging-in-Publication Data
Bissinger, Karl.
The luminous years : portraits at mid-century /
by Karl Bissinger ; introduction by Gore Vidal ;
Catherine Johnson, editor.
 p. cm.
Includes bibliographical references and index.
ISBN 0–8109–4602–5 (hardcover)
1. Celebrities—Portraits. 2. Portrait photography—History—20th century. 3. Bissinger, Karl.
4. Photographers—United
States—Biography. I. Johnson, Catherine. II.
Title.
TR681.F3B58 2003
779'.2'092—dc21
 2003008504

Published in 2003 by Harry N. Abrams,
Incorporated, New York.

Printed and bound in Italy

10 9 8 7 6 5 4 3 2 1

Harry N. Abrams, Inc.
100 Fifth Avenue
New York, N.Y. 10011
www.abramsbooks.com

Abrams is a subsidiary of
LA MARTINIÈRE
GROUPE

Dedicated to my grandsons, Zachary and Sam Fechheimer with love and admiration.

I would like to thank Gore Vidal for his eloquent introduction to this book.

 I would especially like to thank Catherine Johnson for her encouragement, for her interest in my work (most of which has not been published for over fifty years), for her passion and knowledge of the history of photography, for organizing my archives, and for finding the perfect publisher for my long-forgotten collection of portraits.

Editor's Note

When I first began working with and organizing Karl Bissinger's body of work I fell in love with his honest approach to environmental portraiture. He worked as a photographer in an era when assignment portrait photography was an unencumbered collaboration between an editor from the magazine on location and maybe, but not always, a photographer's assistant. There were no wardrobe stylists involved, no celebrity handlers and publicist mandates, and no make-up artists. Karl's choice of location for the sitting was most often where the person lived or worked. The end result was never retouched, except in one instance; he had the scratches on the face of Jane Bowles retouched on the print, but not the negative. Although no photograph is truly truthful, in the world of portraiture Karl Bissinger's images come close.

 I would like to thank, first of all, Berenice Lanning for introducing me to Karl, and I would like to thank Karl for trusting me with his work.

 I would especially like to thank Christopher Sweet of Harry N. Abrams. Also Jennifer Gyr, Sergio Purtell of Black & White on White, and his team of printers; Margaret Gibbs of New York Film Works; and Jon Rosen of Nucleus. And Thomas Melvin, my brother-in-law, who luckily for me is also a research librarian; he can check a fact and source a source faster than anyone I know. I am also very grateful to the following friends and colleagues who helped me resource and track down facts and biographical information: Cynthia Cathcart of the Condé Nast Library, Joanna Steichen, Theodora Roosevelt Keogh, Dr. Ana-Börger Greco, and Ellen Marenek. Also Rebecca Johnson Melvin, Nike and Nile Lanning, Alvin Booth, David Redding, Scott Richards (the master sorter), Carlos and Carla Gomez, Sarah Foelske, Dr. Stanley and Sara Burns, Chris Paculli, Jeanne Byers, Rochelle Klein, Leyla Basakinci, and Anne Lacombe. And, as always, Glenn and Lucie Johnson.

Catherine Johnson

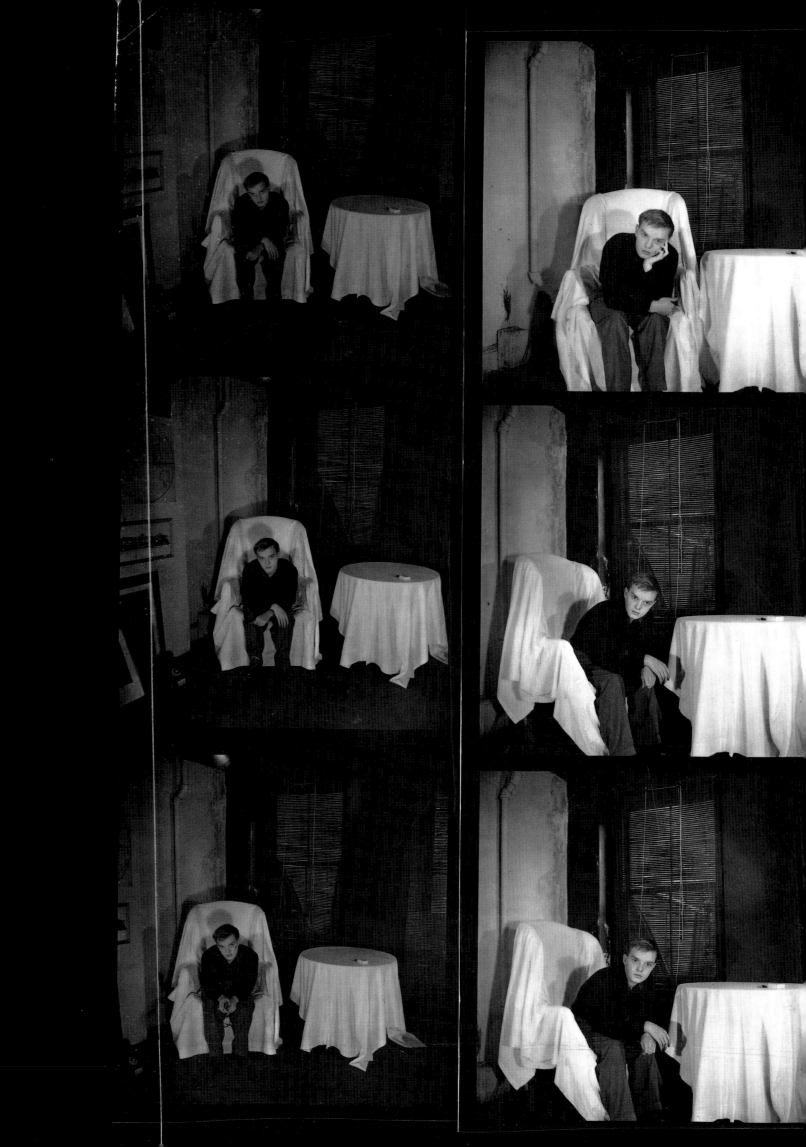

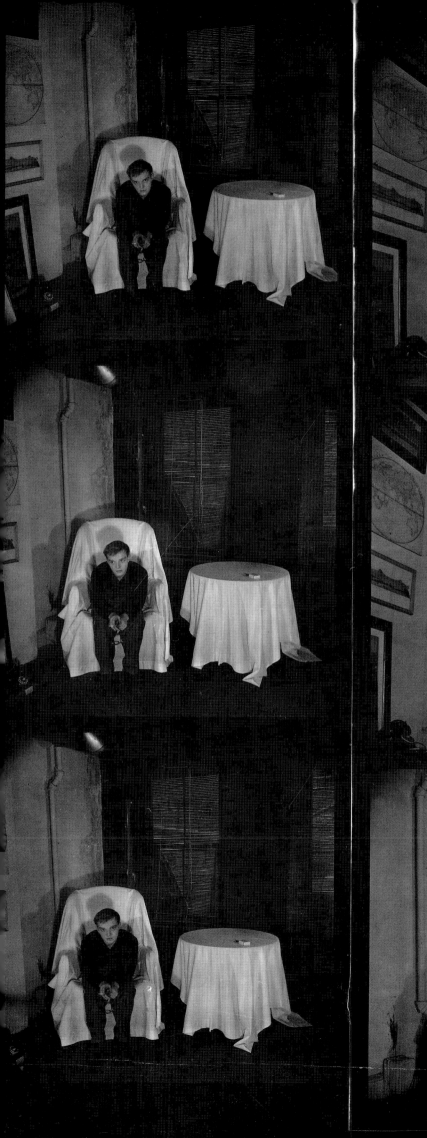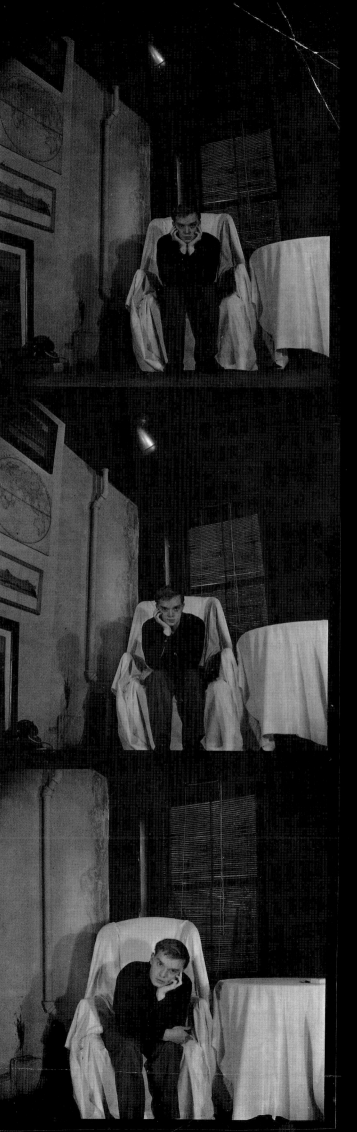

Introduction by Gore Vidal

One warm New York day in 1949, Tennessee Williams, whom I had met the previous summer in Italy, and I were approached by an editor for a new magazine called *Flair*, the invention of Fleur Cowles. Would we allow Karl Bissinger to photograph us in the patio-garden of Café Nicholson, along with ballerina Tanaquil Le Clercq, painter Buffie Johnson, and Tennessee's old friend, writer Donald Windham? For more than a half-century, whenever anyone asks me about the postwar 1940s and what it was like, I always say look at Karl Bissinger's photograph of us in the first issue of *Flair*. There we all are. And such is the magic of his art that, though we are shown in black and white, the encompassing light appears golden. And we are young. We had survived the Depression and World War II. We had also flourished during the three years of peace prior to the photograph – years that we assumed were prelude to a golden age, never suspecting that only two years later the Korean War would begin and the gold would go out of the light. A near century of perpetual war has made Bissinger's study oddly haunting. We are figures from a long-ago time – more 1848 than 1948.

Did I suspect what was to come? Hardly. But I do notice in pictures from this period how I am always the one who is looking out of frame. At what? I still wonder.

Bissinger seems to have been court photographer to Truman Capote, easily the most photographed writer of our brief golden age. As I study his photographs of Truman, I am struck by how expressionless Truman is. In life he was an ardent, if not always reliable, gossip with a most animated face. Here he looks strangely blank. Then I recall his fantasy of himself that season. When he told me that his new novel (never written) would be about a beautiful New York debutante, I asked, "What on earth do you know about them?" "*Everything*," he said, tossing his head. "After all, *I* am one." He had also picked up a mannerism reminiscent not so much of debutantes as of the great models and other beauties: a total blankness of expression. (Check out Ingrid Bergman's last close shot in *Casablanca* where she hasn't yet been told how the picture ends.) Happily – or unhappily – most of Bissinger's subjects have been let in on that great mystery by now, and soon the rest of us . . .

Bissinger deals in high Bohemia, the world of the arts, as well as strange celebrities like the Windsors. Here is Henry Miller in his Chinese mandarin phase. The truly glamorous Jean Marais is seated on the sink of what looks to me to be the kitchen in the Palais Royal flat he shared with Jean Cocteau, a row of homely French detergents back of him and a worried frown betraying a

domestic side Cocteau never captured in his movies. Colette is, as always, magnificent with hard carven features, not unlike a masculine Cocteau.

Photographed from the front, Jean Renoir has a shiny baldhead while a mirror just back of him shows what looks to be, disturbingly, a full head of hair. We are in Magritte-land. Renoir reads a paper, morning coffee before him. We have the sense of ritual enactment. A demitasse. A white marble table. Surrealism is alive in these pictures: life, too. The mood even rubs off on Dean Martin and Jerry Lewis, who first joined forces in 1948. Bissinger's camera makes them mysteriously handsome, which their comedy could not. Or, perhaps, one should say comedy requires an element of the grotesque that Bissinger's eye ignores when it is not staged for him. He shows us only what's there; particularly if it's unexpected. Hoagy Carmichael sits at a piano and looks like the songs he writes. We see Montgomery Clift before his face was half-paralyzed in an automobile accident. I wrote the screenplay for *Suddenly Last Summer;* when the producer Sam Spiegel heard that I was going to be at a party with Clift at Norman Mailer's, where we read Norman's play *The Deer Park*, Spiegel said: "Watch him like a hawk. Tell me if he gets drunk. We can't have that on this picture." I watched him like a hawk. He got drunk. I told Sam, "He drank only Coca-Cola." On the picture he could not work after lunch – painkillers, not alcohol. Joe Mankiewicz, for some reason, hated him, and in one scene Monty must hold a document and read from it. His hand shook so that the sound effect was like that of a forest fire. Joe made him shoot the scene a dozen times.

Paul Bowles is his usual immaculate self in a Paris suit made in the 1930s. He smoked kif nonstop. From kif, he liked to say, came some of his most exotic work. Bissinger catches, in only one shot, that fugitive look of apprehension which appears more in his work than in his face. A claustrophobe, Tennessee Williams always feared suffocation. He strangled to death from inhaling the cap of a plastic spray bottle, "What one most fears," I wrote Paul, "must fearfully happen."

Here is Walter Lippmann, a family friend. I was once in the tailor's room at New York's Brooks Brothers store. Lippmann, in a new suit, was staring intently at his face in the mirror. Identity check? The last time I saw him and his wife, Helen, was in Rome. They were in a joyous mood. "Why so happy?" I asked, "Because," said Helen, "we have just decided that we are never, ever going to Japan." Walter nodded, "It has been the Sword of Damocles hanging over my head for half a century."

In these early shots, James Baldwin is still very much the boy preacher. The Duke and Duchess of Windsor are like exquisite museum dummies designed to show off costumes. Some of their many dogs look attractive. She was a 1920's-style wisecracking flapper. She made you laugh. He was dim. Bertie Wooster who had strolled by accident into history without Jeeves. She often used the tone of a dominatrix with him. "Pull up your socks, David," she shouted at one dinner party.

Tallulah Bankhead looks amazingly like my mother, a friend of hers as well as a fellow Congressional flapper. Mark Blitzstein seems ready to start talking, often brilliantly. He is at the piano – writing the score of *Regina?* He was murdered by French sailors somewhere in the Caribbean. Here is Charles Boyer, a great actor in French (*Madame de*), if not English. I worked on *Is Paris Burning?* All the French stars appeared. At first, Boyer said no. Then he burst into tears. "I was not in France. I fled to America." But he was in the picture. Marlon Brando is unrecognizably thin, posed in a round porthole. There is a picture of a hard Spanish writer I much admired in the 1940s, Camilo José Cela. His novel *The Hive* still lives on in my head. A fascinating Piscatoresque photograph of choreographer Agnes de Mille at work. An unglamorous shot of José Ferrer, because comedy intrudes: he was a wit. When his wife's nephew, George Clooney, appeared in his first play he ate up the proverbial scenery. When Uncle Joe came backstage, Clooney asked him what he thought. Joe was kindly. "Be very careful, my boy, when you chew scenery because you never know where it has been." Alec Guinness is shown in sly good form. We were both involved in a bad film but remained amiable. I last saw him in London. He said he was moving from country to town, to the hotel where each of us stayed. "I'll see you tomorrow," he said. "No, I'm off to Pittsburgh." "Why Pittsburgh?" "I'm acting in a film called *Bob Roberts*." Guinness winced. Then, low husky voice, "How long will you be in Pittsburgh?" I said, "Two or three days." He was suddenly radiant. "Oh, a *small* part!"

The poetic Robinson Jeffers is revealed looking suitably magnificent beside the Pacific where he lived in a stone tower and wrote poems in which hawks – that looked just like him – constantly circled. He did a version of *Medea* for Broadway, which starred Judith Anderson, who did quite a bit of scene-chewing herself. As Anderson took her curtain calls, Joan Crawford walked up the aisle to the exit, saying to no one in particular, "I would have played it differently." But then, as she once chided a journalist, "Whom is fooling whom?"

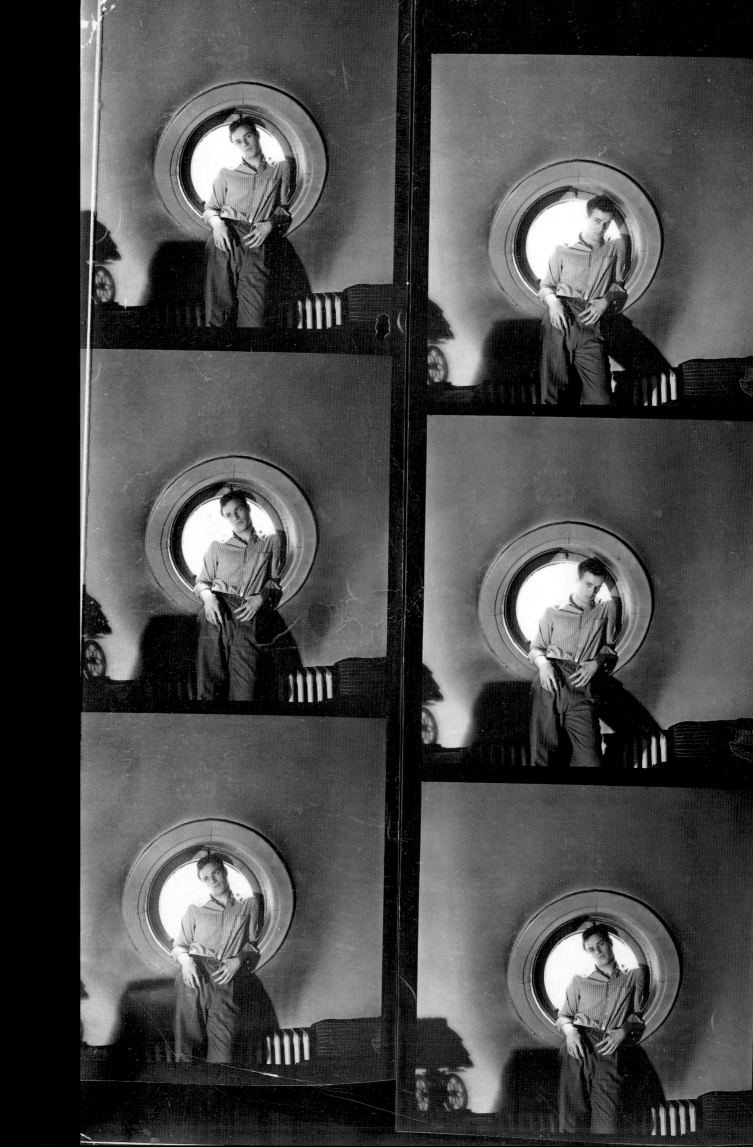

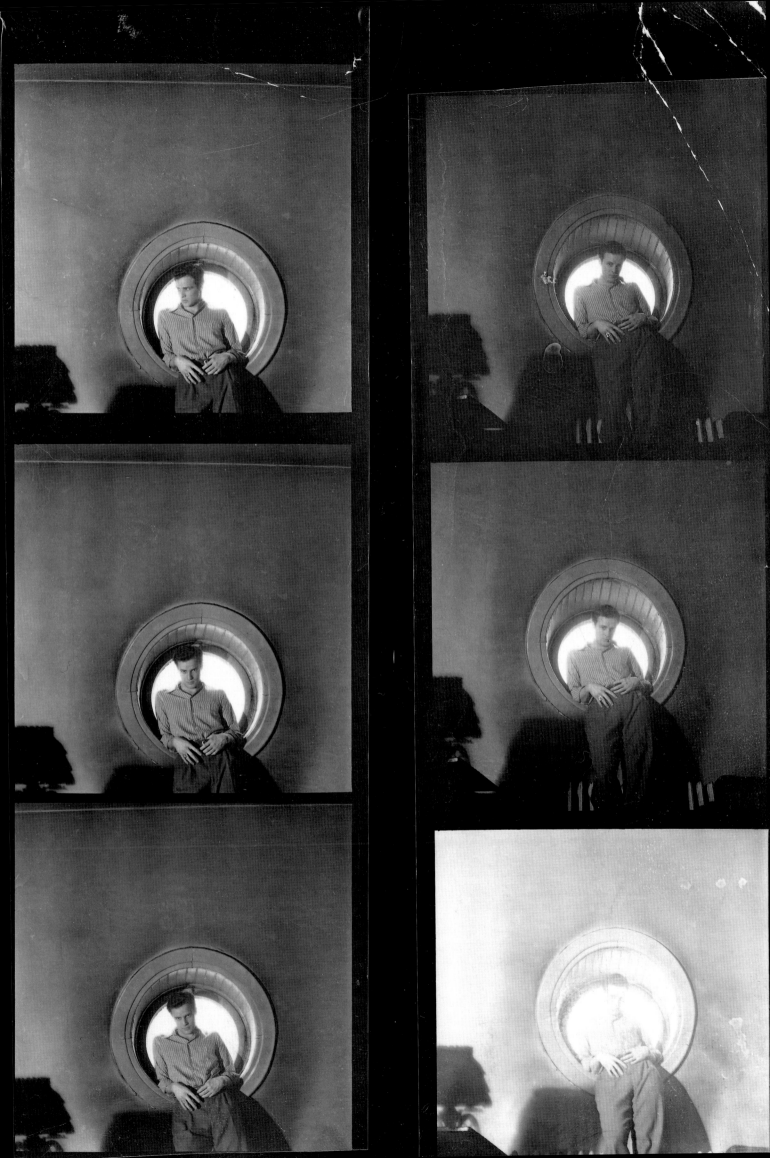

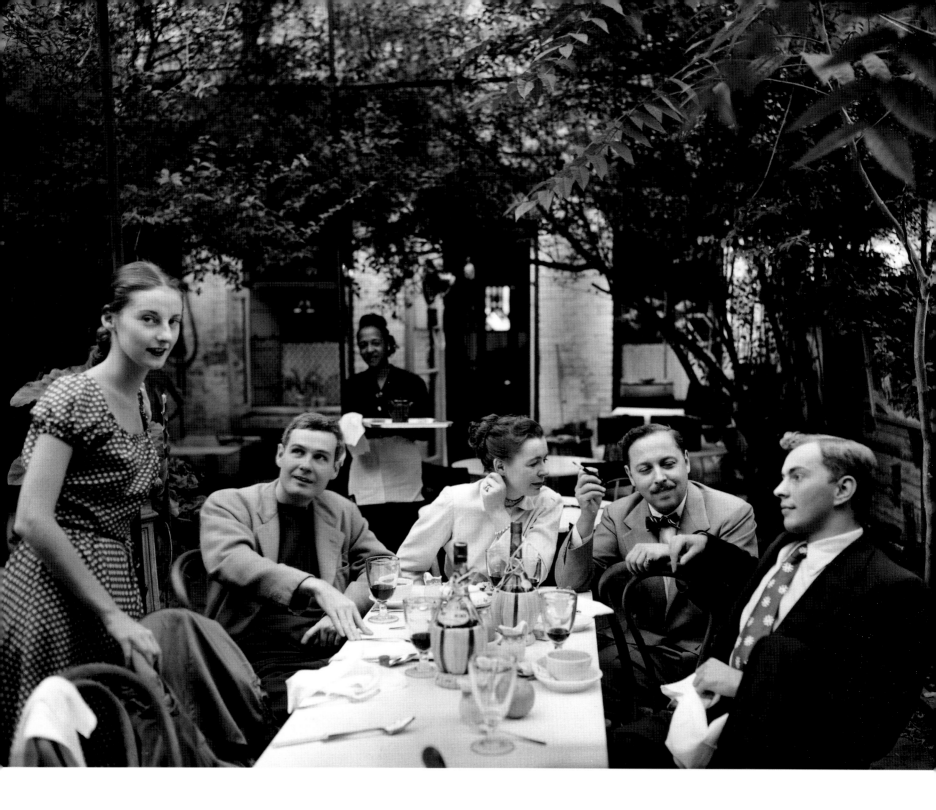

Left to right: Tanaquil Le Clercq, Donald Windham, Buffie Johnson, Tennessee Williams, and Gore Vidal, with Virginia Reed in the background, in the garden of Café Nicholson, 1949

15

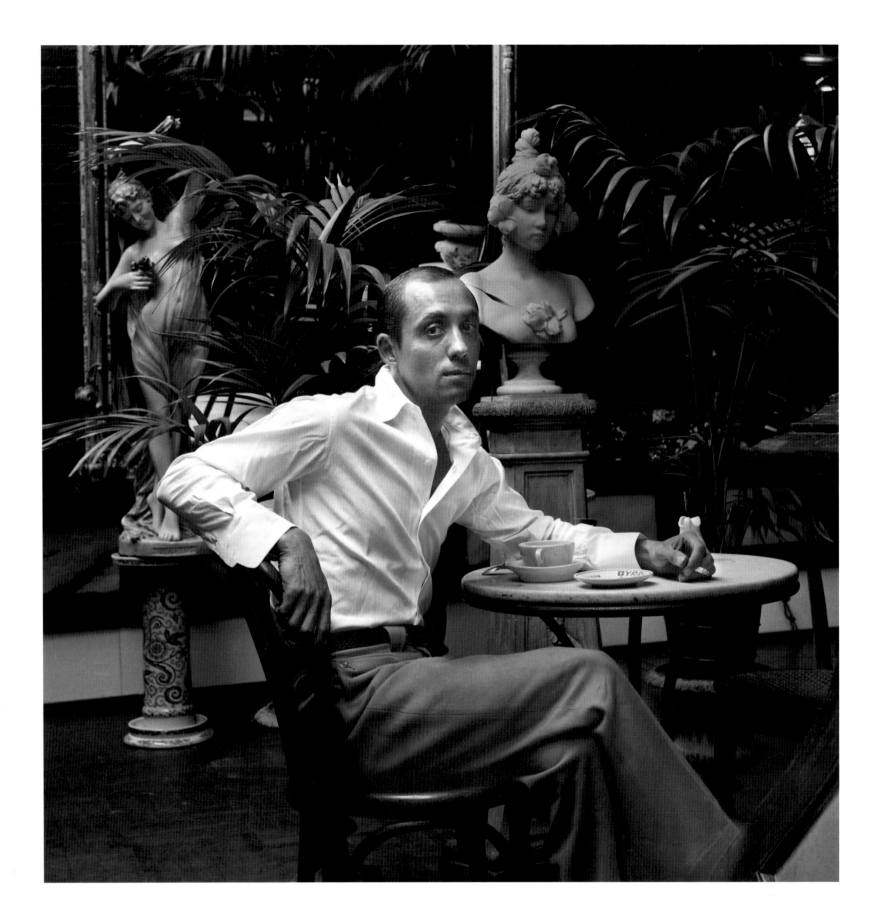

Johnny Nicholson, proprietor of Café Nicholson, early 1950s

Tanaquil Le Clercq, 1950

16

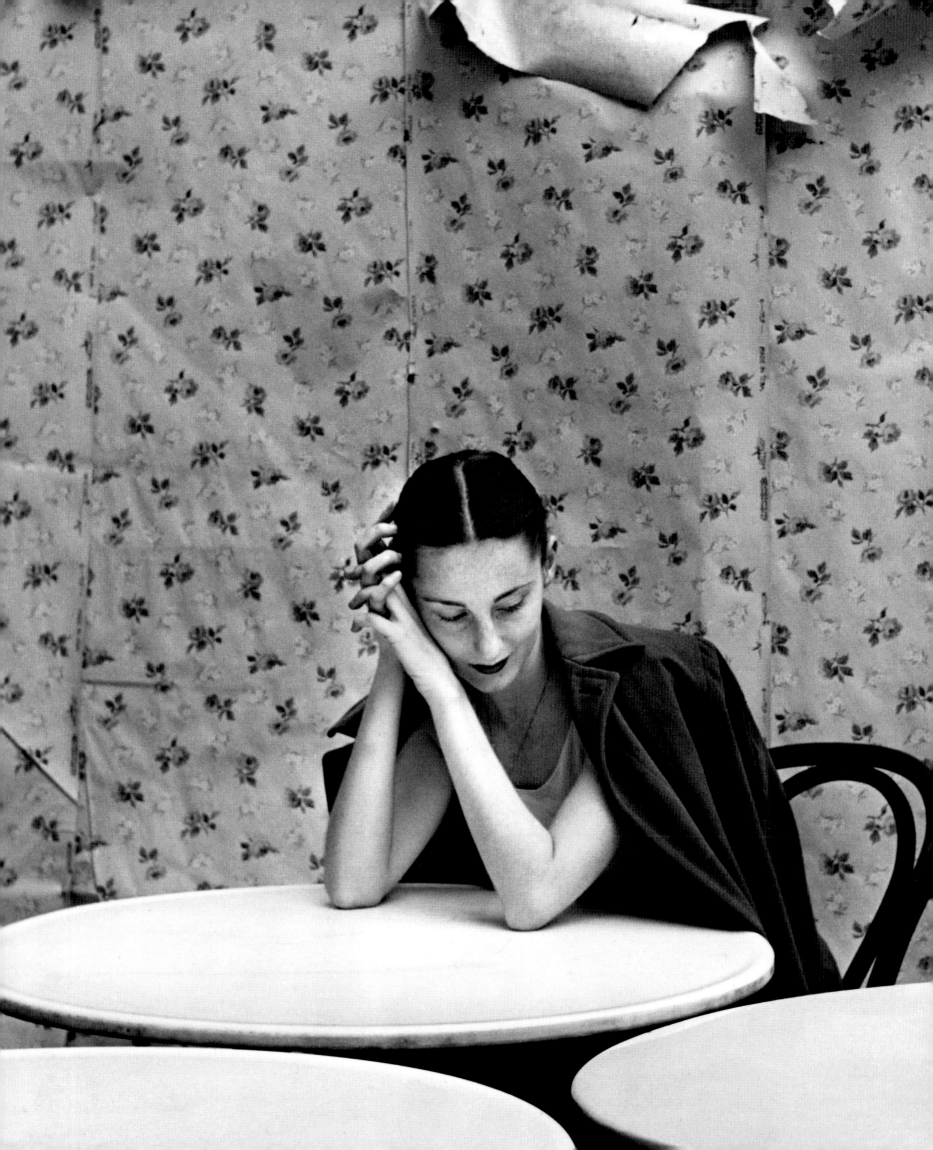

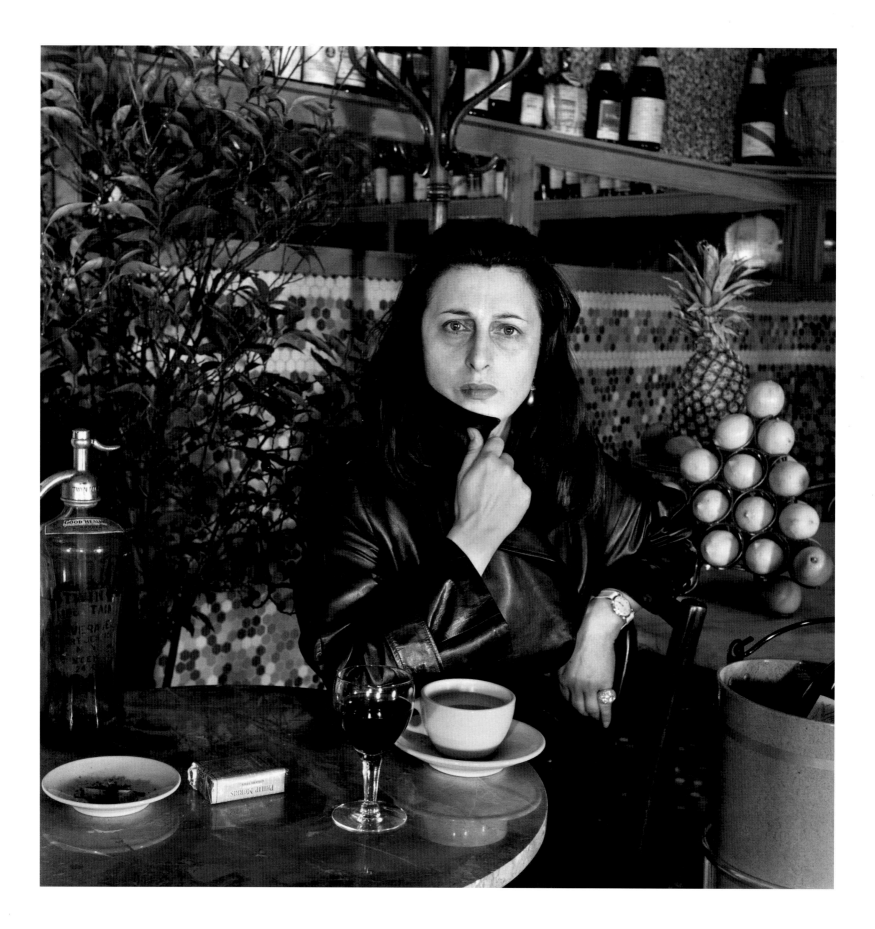

Anna Magnani at Café Nicholson, New York, early 1950s

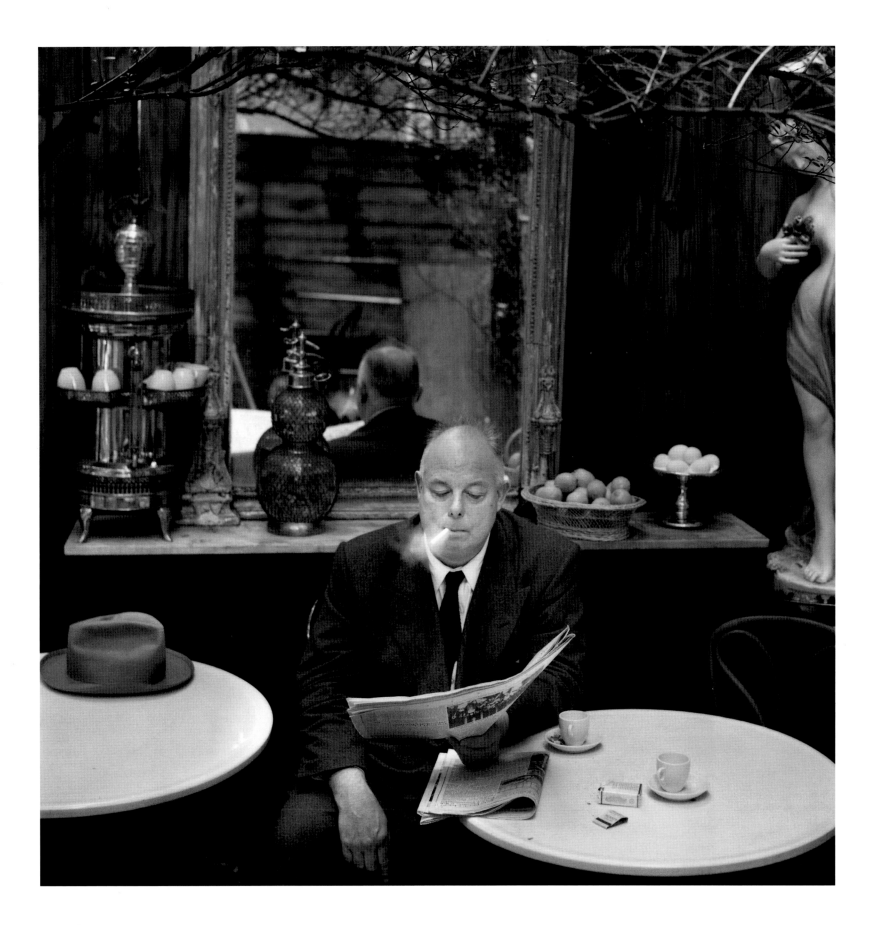

Jean Renoir at Café Nicholson, New York, 1950

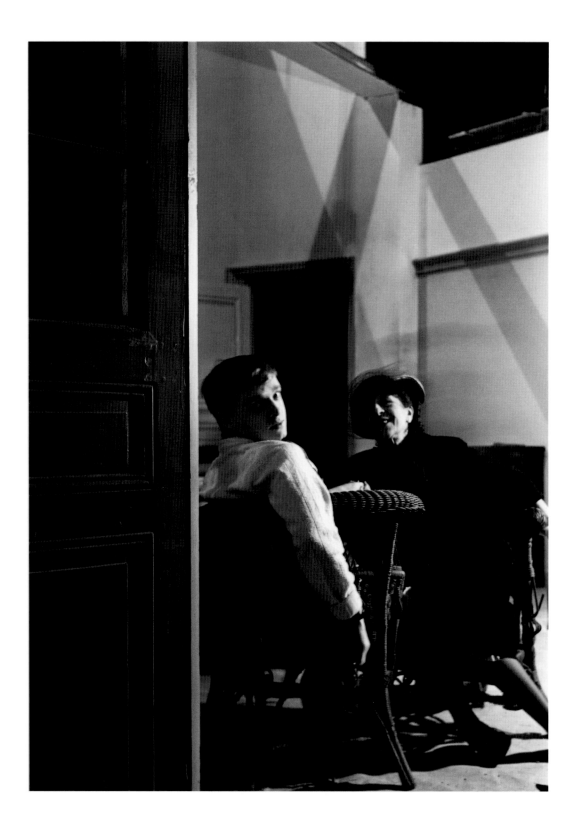

Truman Capote and Marie-Louise Bousquet, editor of the French edition of
Harper's Bazaar, on the set of *Les Parents terribles,* Paris, 1948

Truman Capote at Beekman Place on the steps down to the East River, New York, 1947

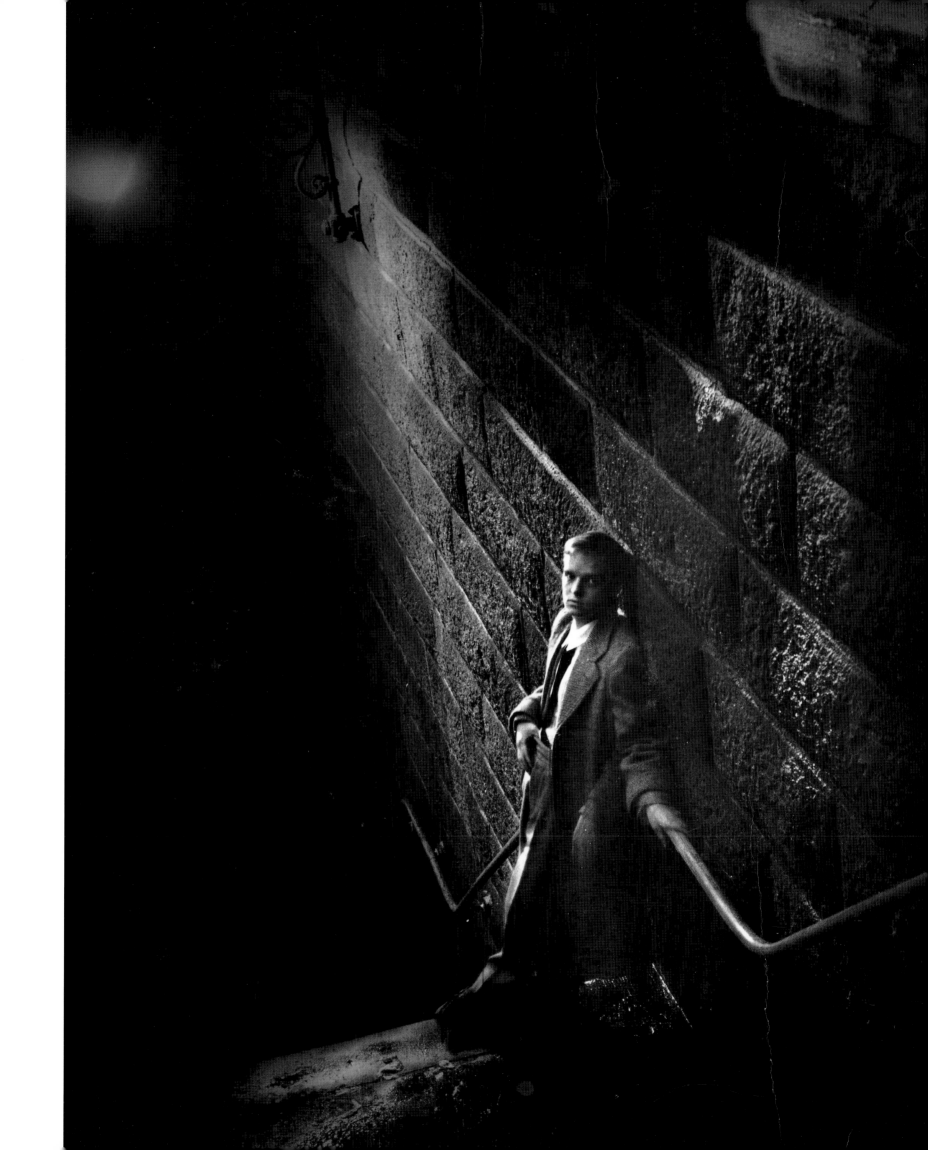

Truman Capote, Paris, 1948

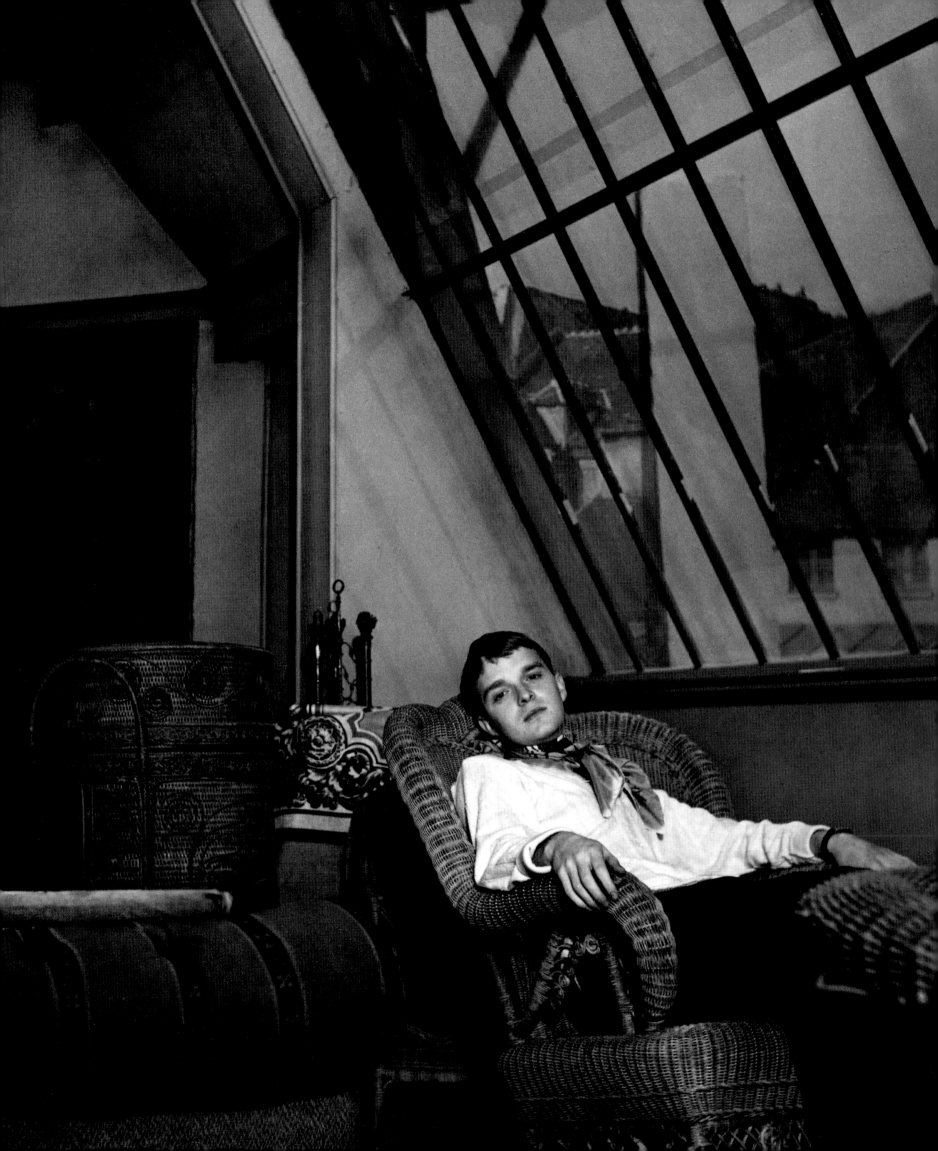

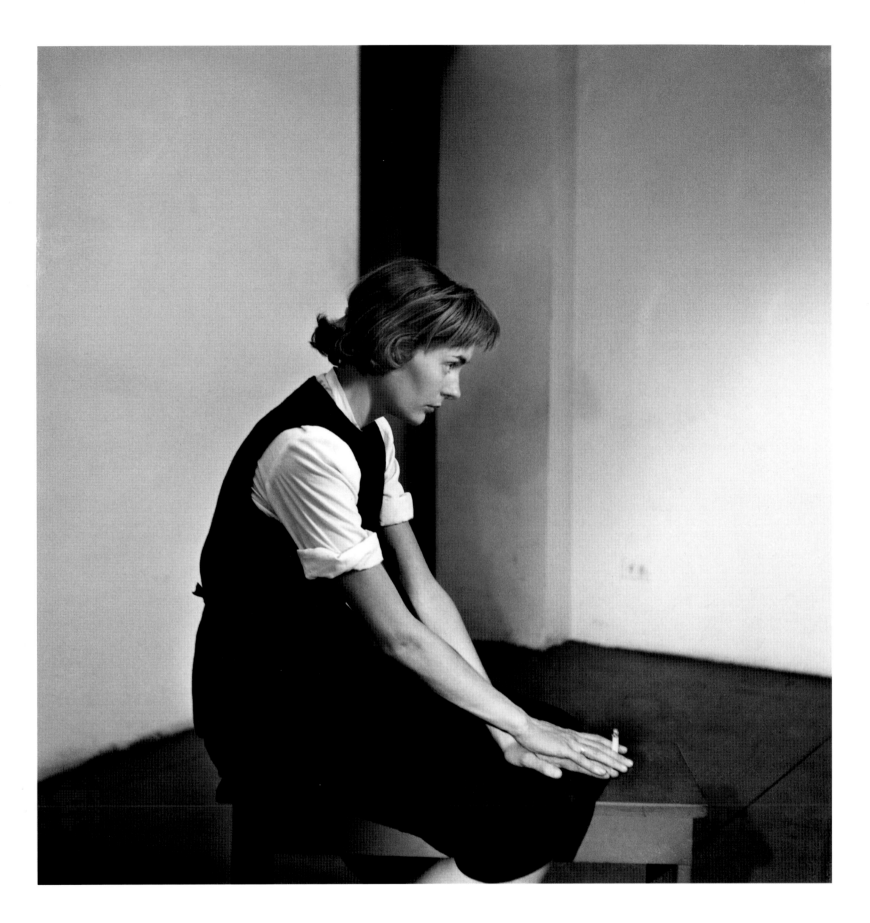

Doe Avedon, 1947

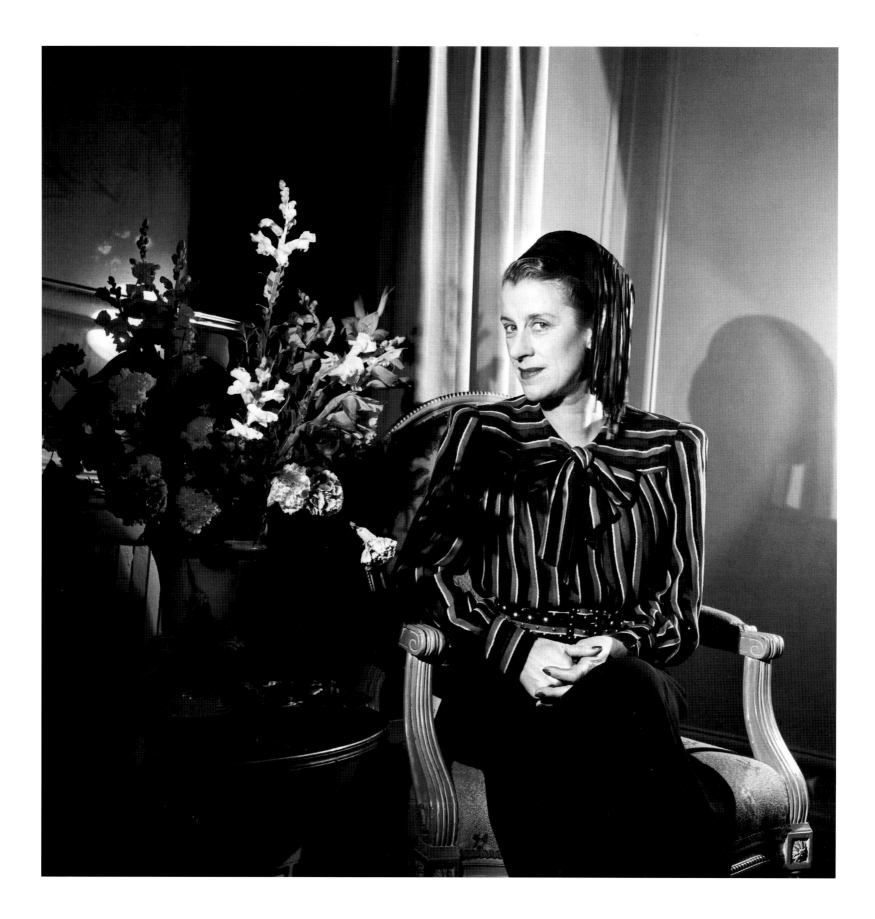

Beatrice Lillie, 1952

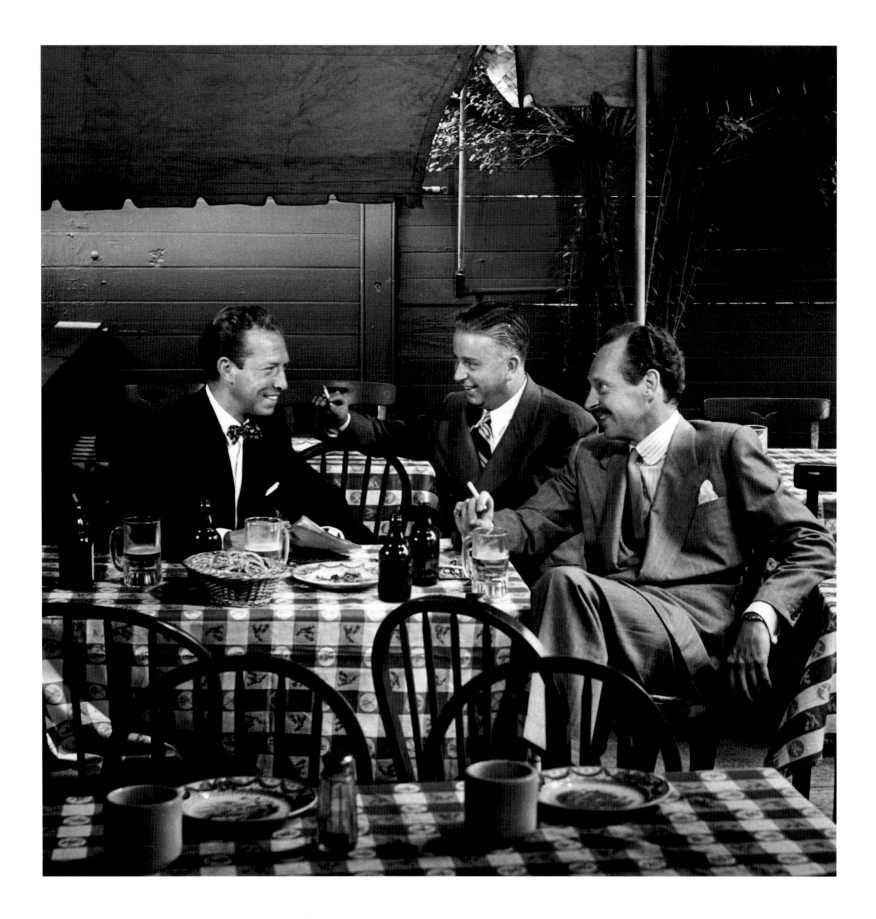

Left to right: Stewart Chaney, John Van Druten, and Alfred de Liagre, Jr., 1947

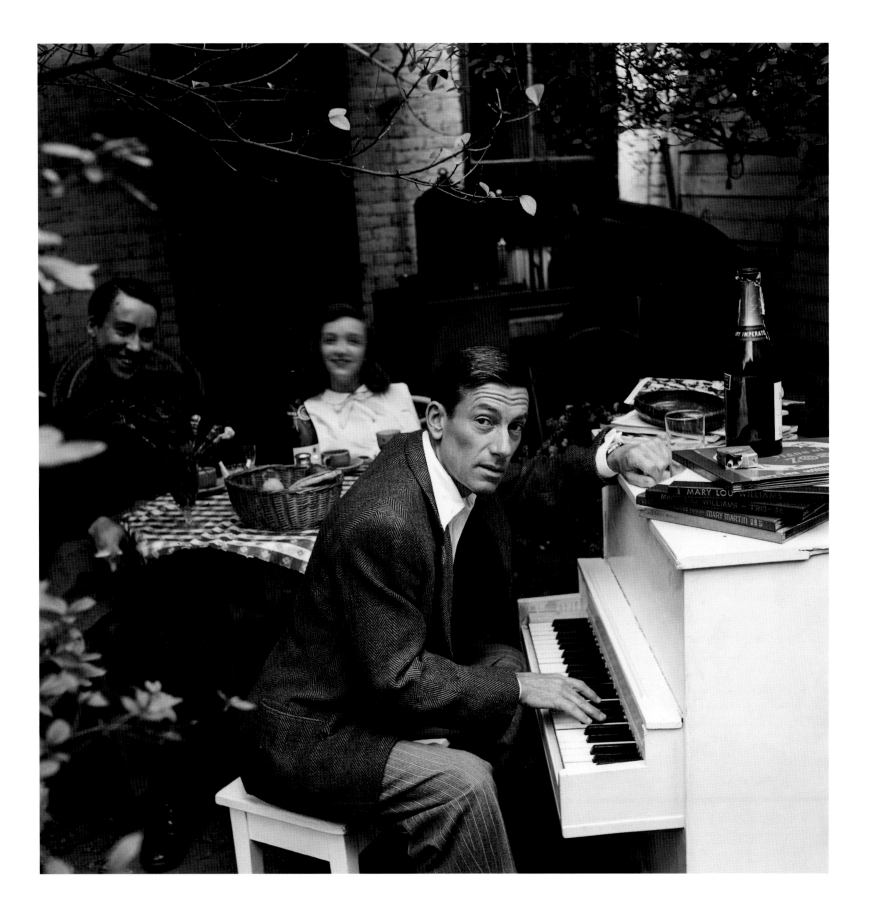

Hoagy Carmichael with artist Charles Owens and editor Jean Lavender, 1947

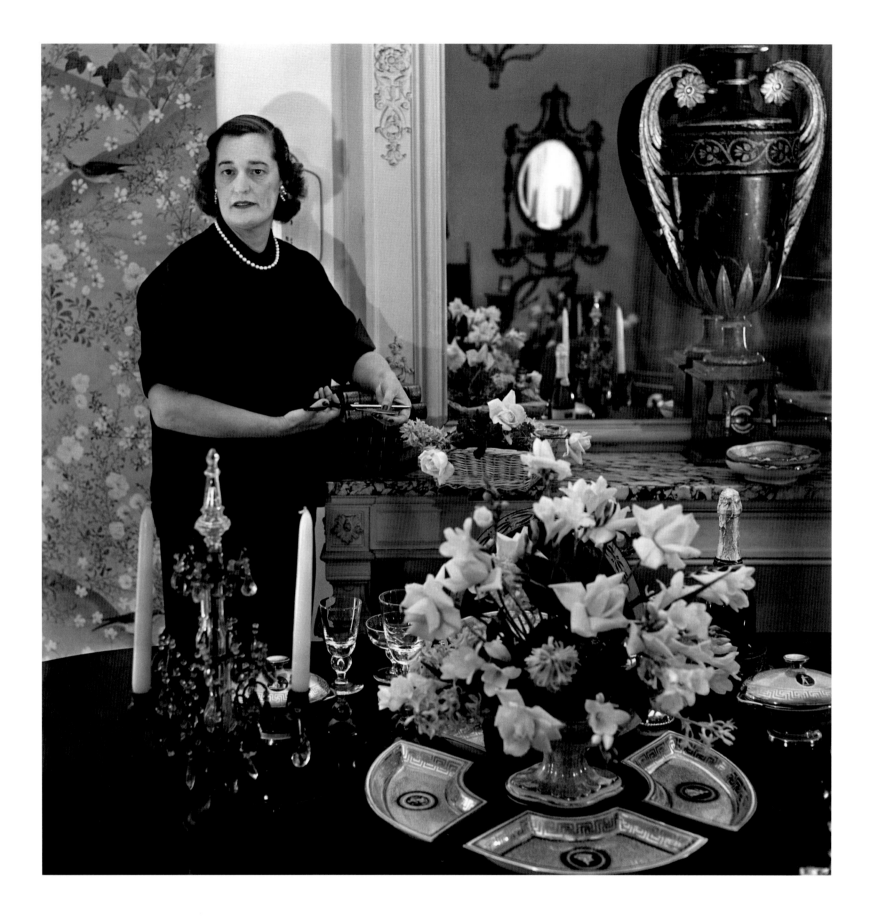

Sister Parish at home, 1950

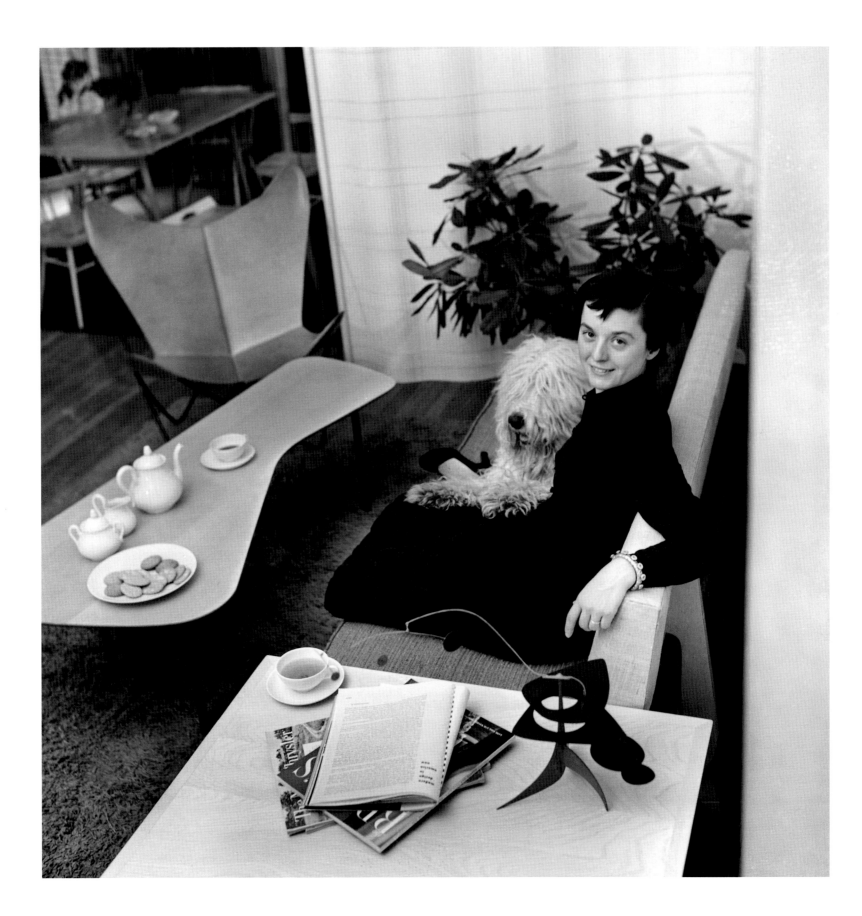

Florence Knoll in the Knoll Associates showroom, 1950

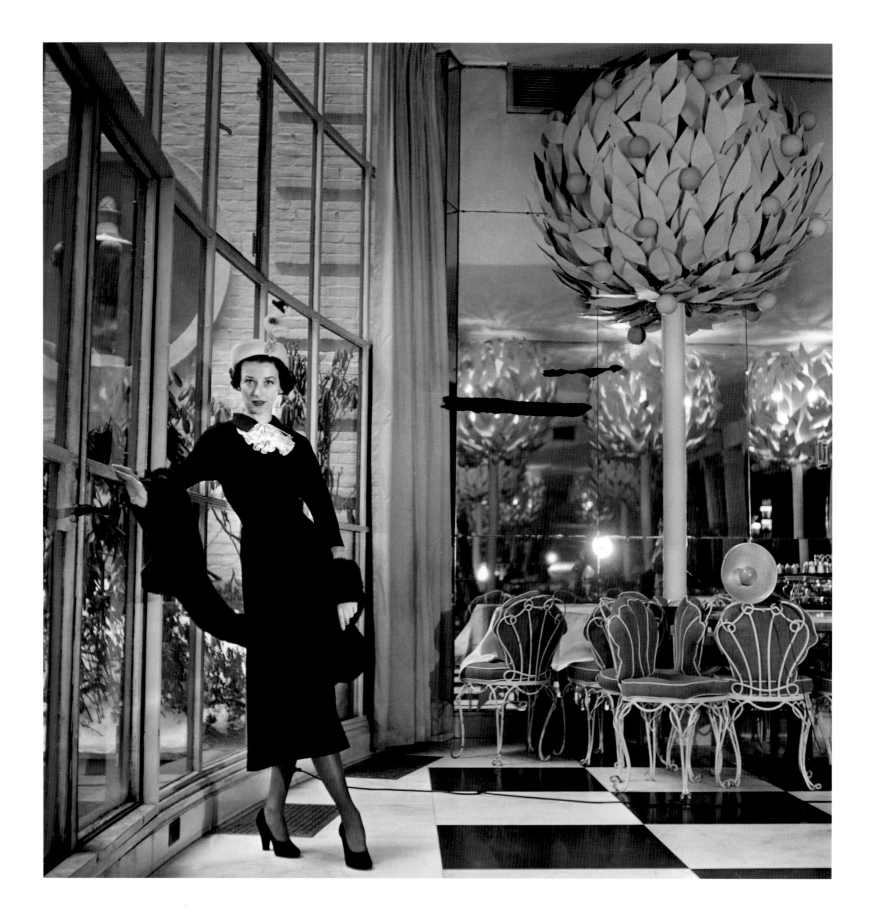

Dorian Leigh, 1950s

The Fontana Sisters, Rome, 1951

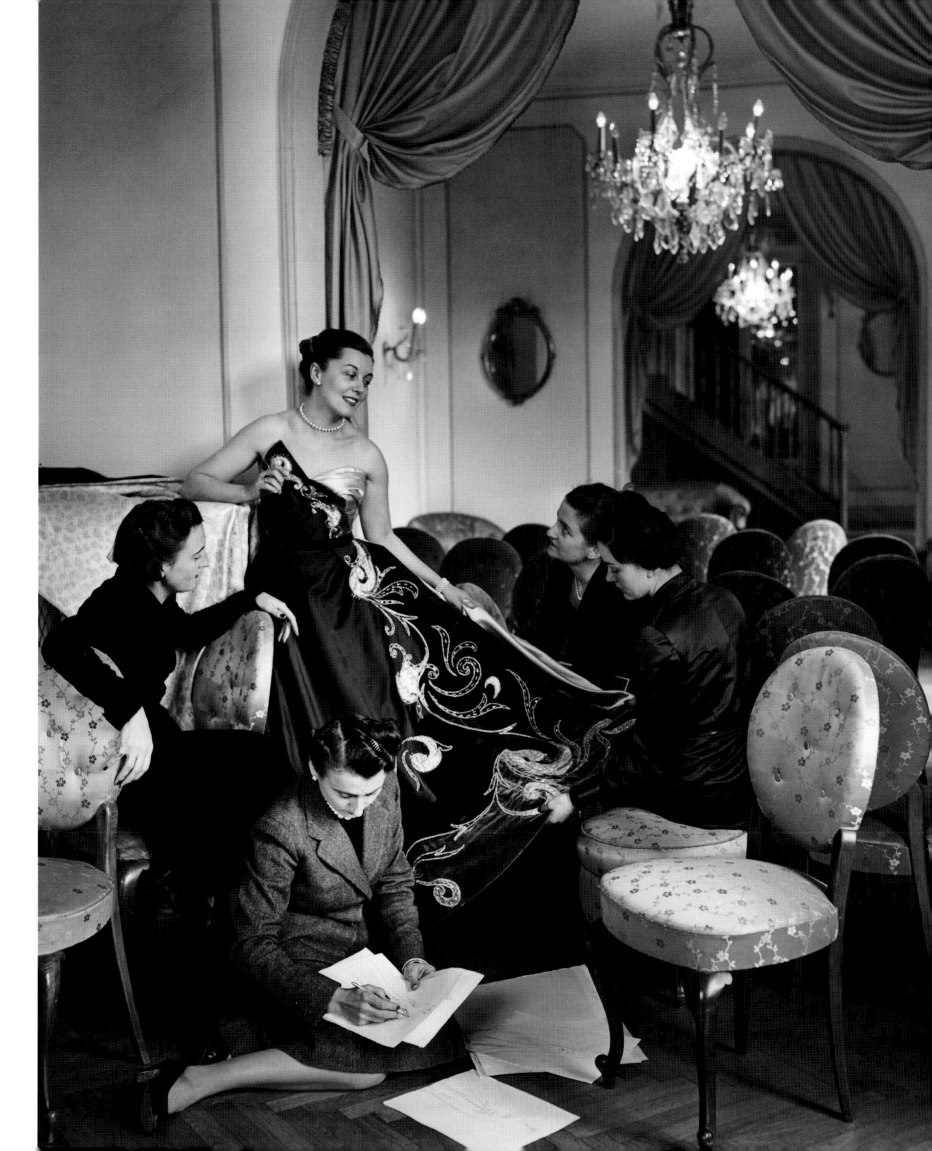

Mainbocher in his New York atelier, 1951

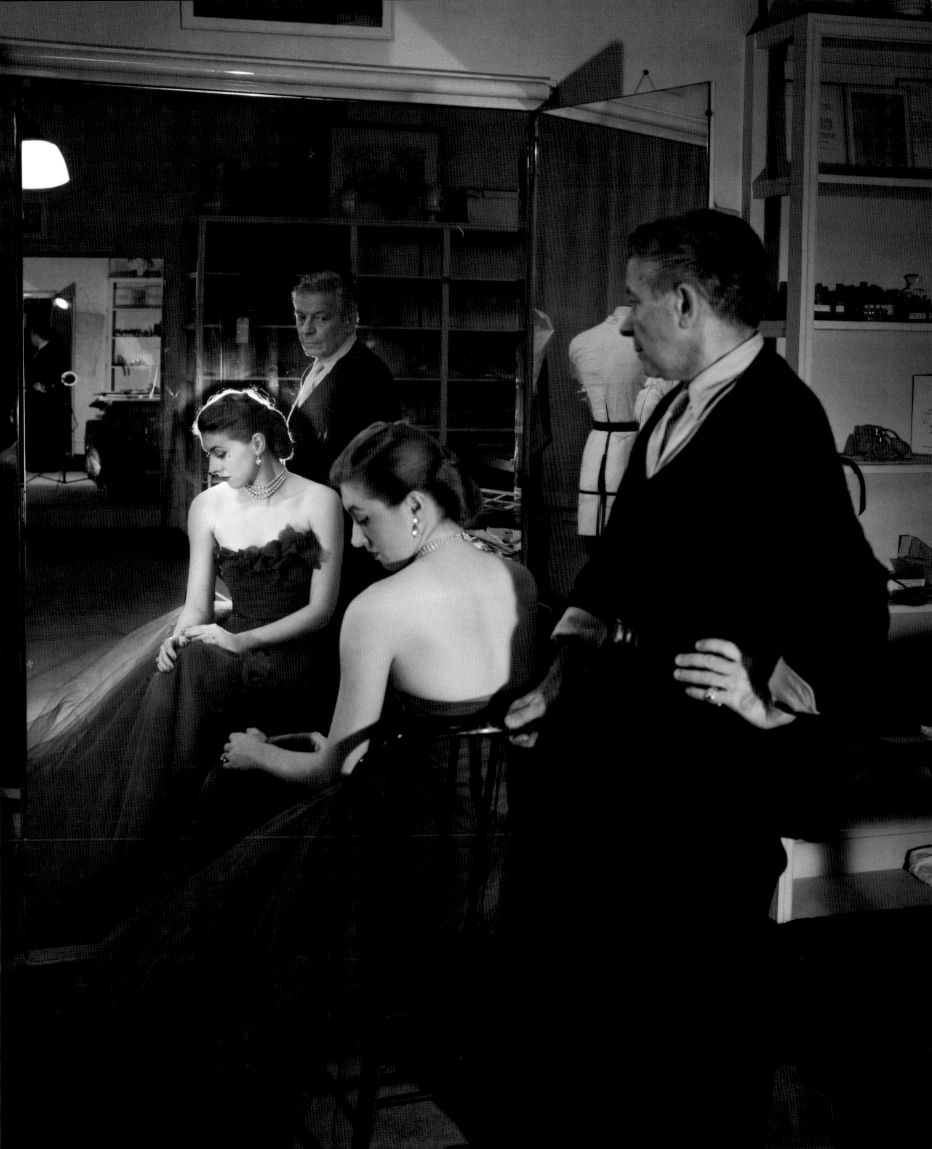

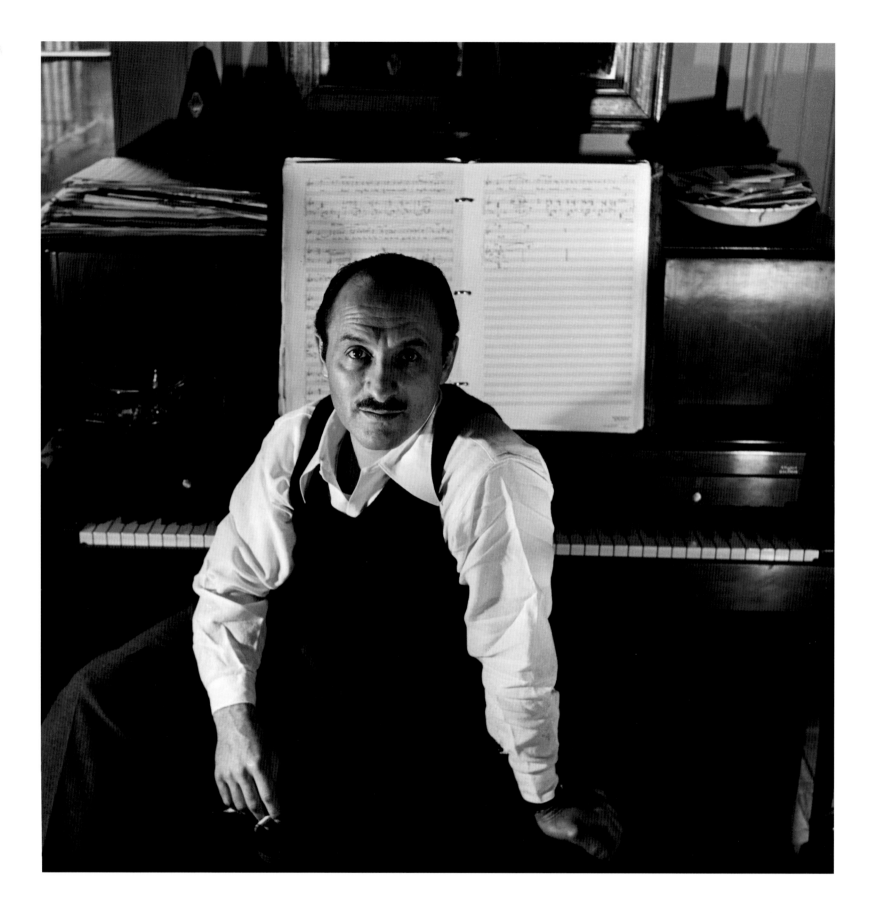

Mark Blitzstein, c. 1950

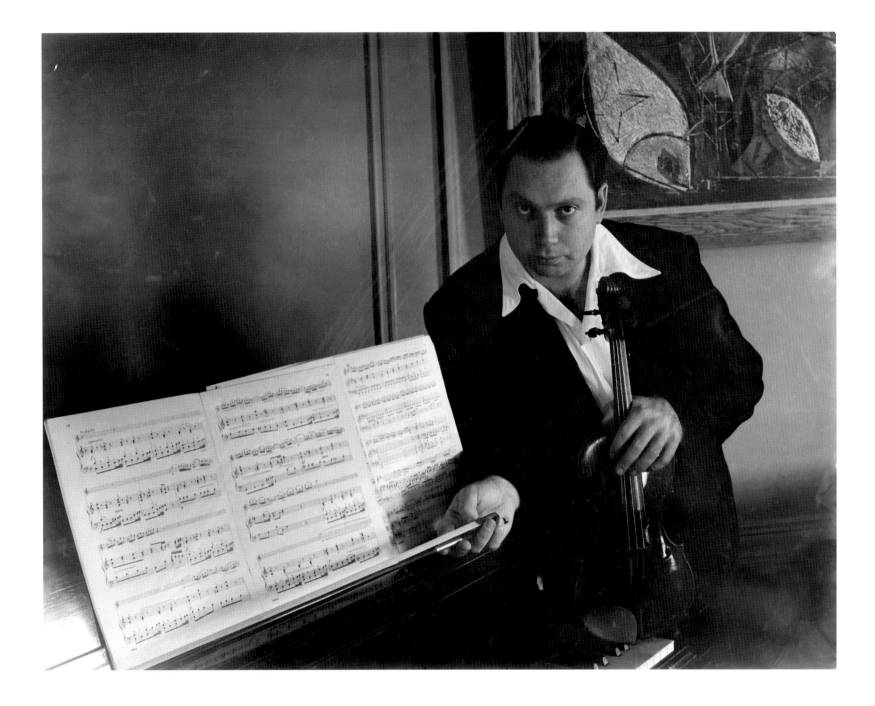

Isaac Stern, c. 1954

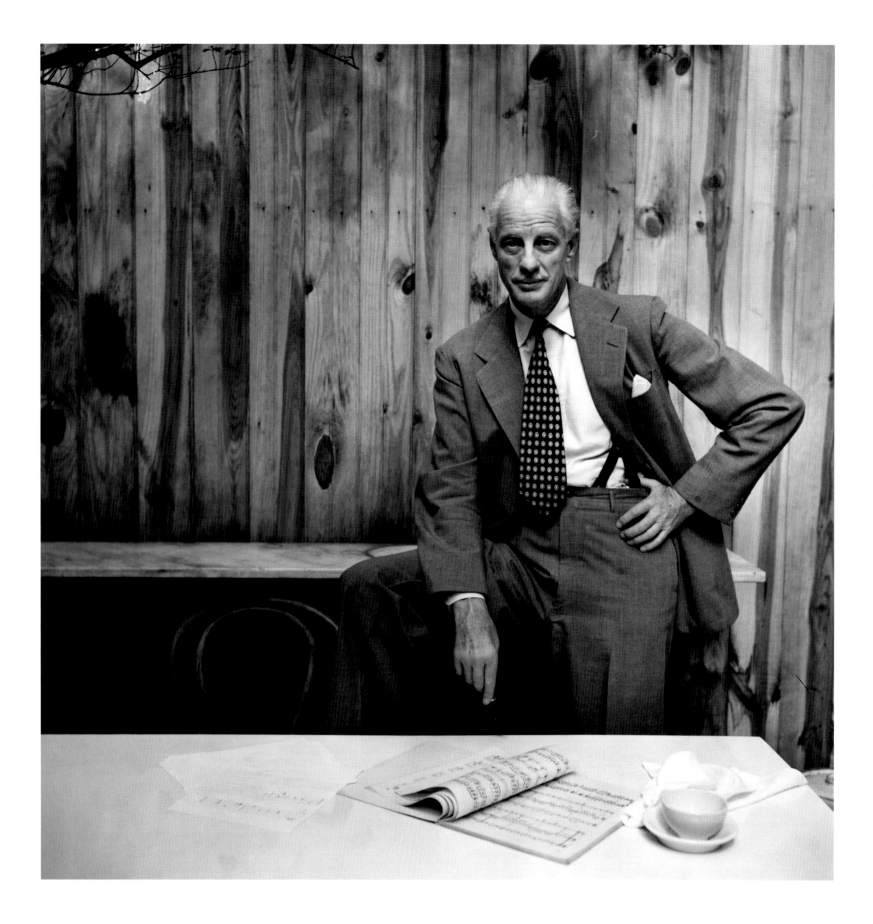

Robert Russell Bennett, 1949

Carol Channing at the time she was starring on Broadway in *Gentlemen Prefer Blondes*, 1949

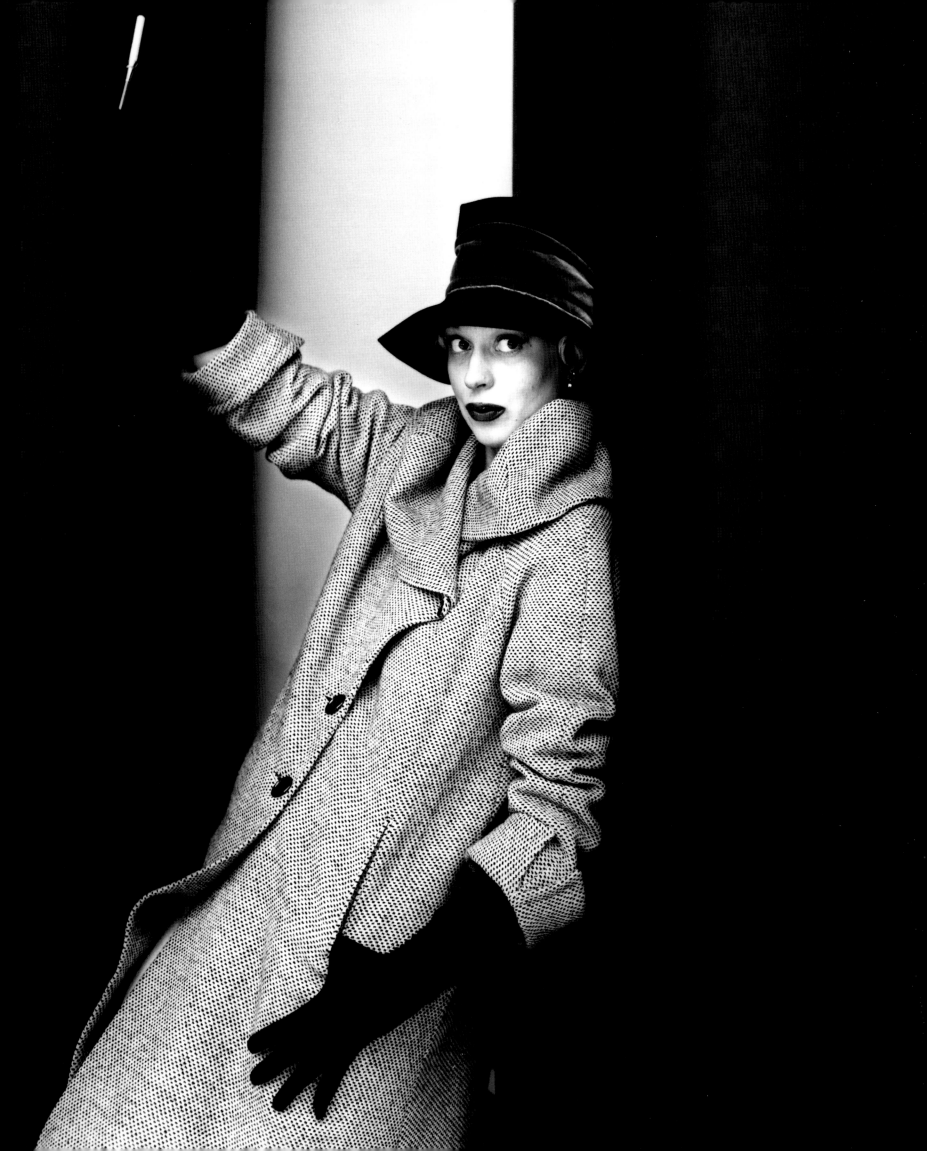

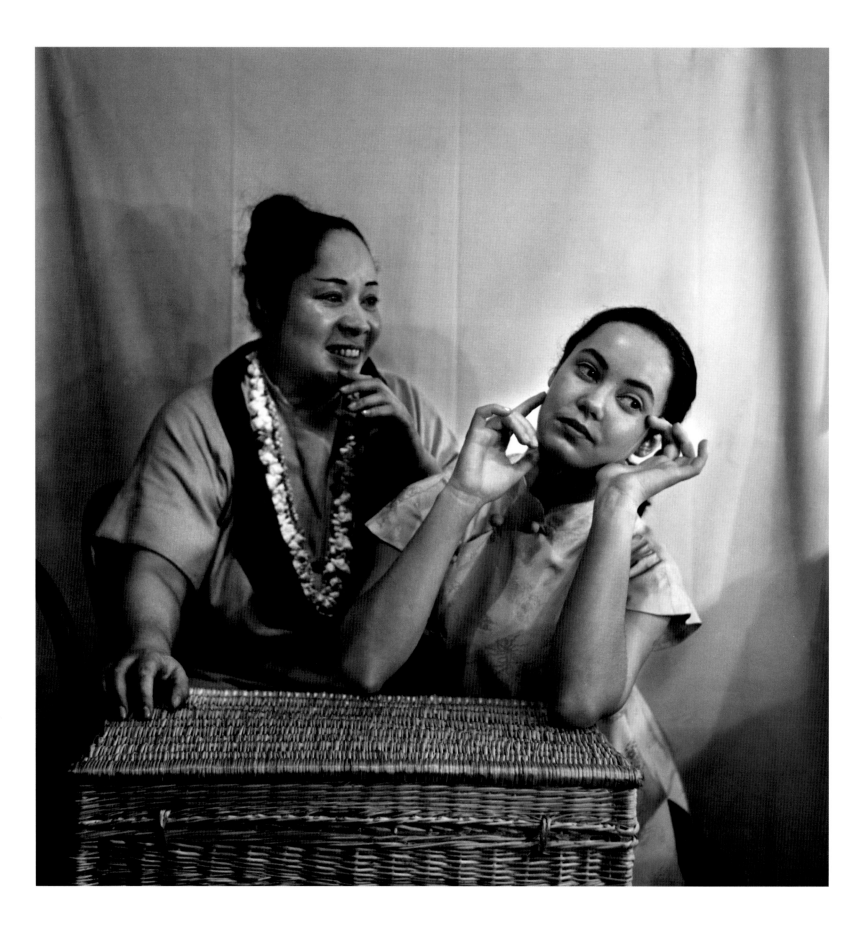

Juanita Hall and Betta St. John of the original Broadway cast of *South Pacific*, 1949

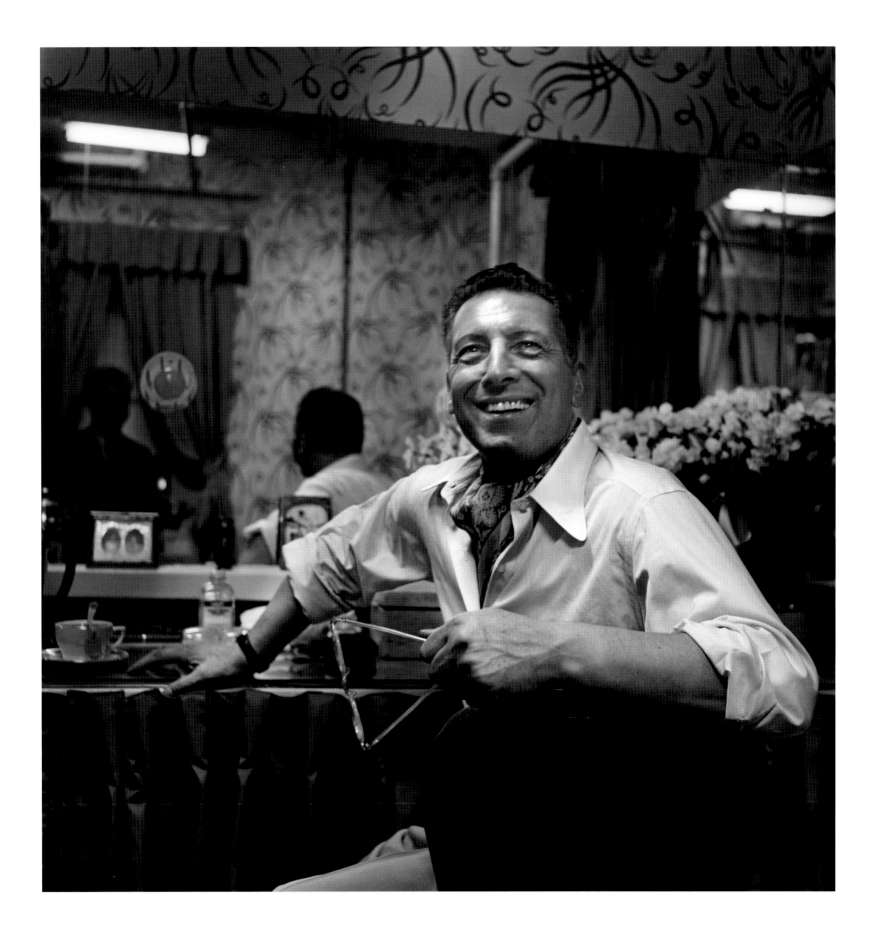

Ezio Pinza, star of *South Pacific*, in his dressing room, 1949

Rex Harrison and Joyce Redmond performing on Broadway in *Anne of the Thousand Days,* 1948

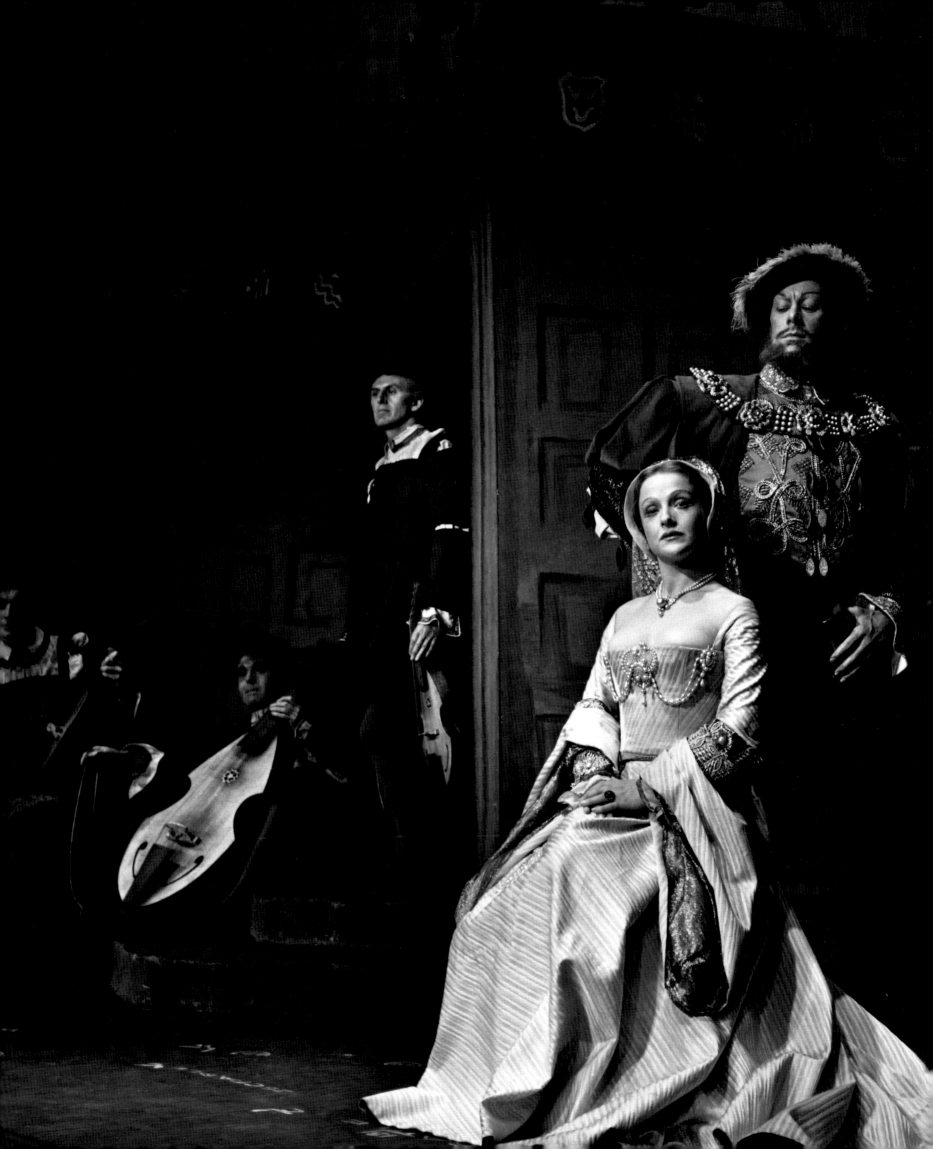

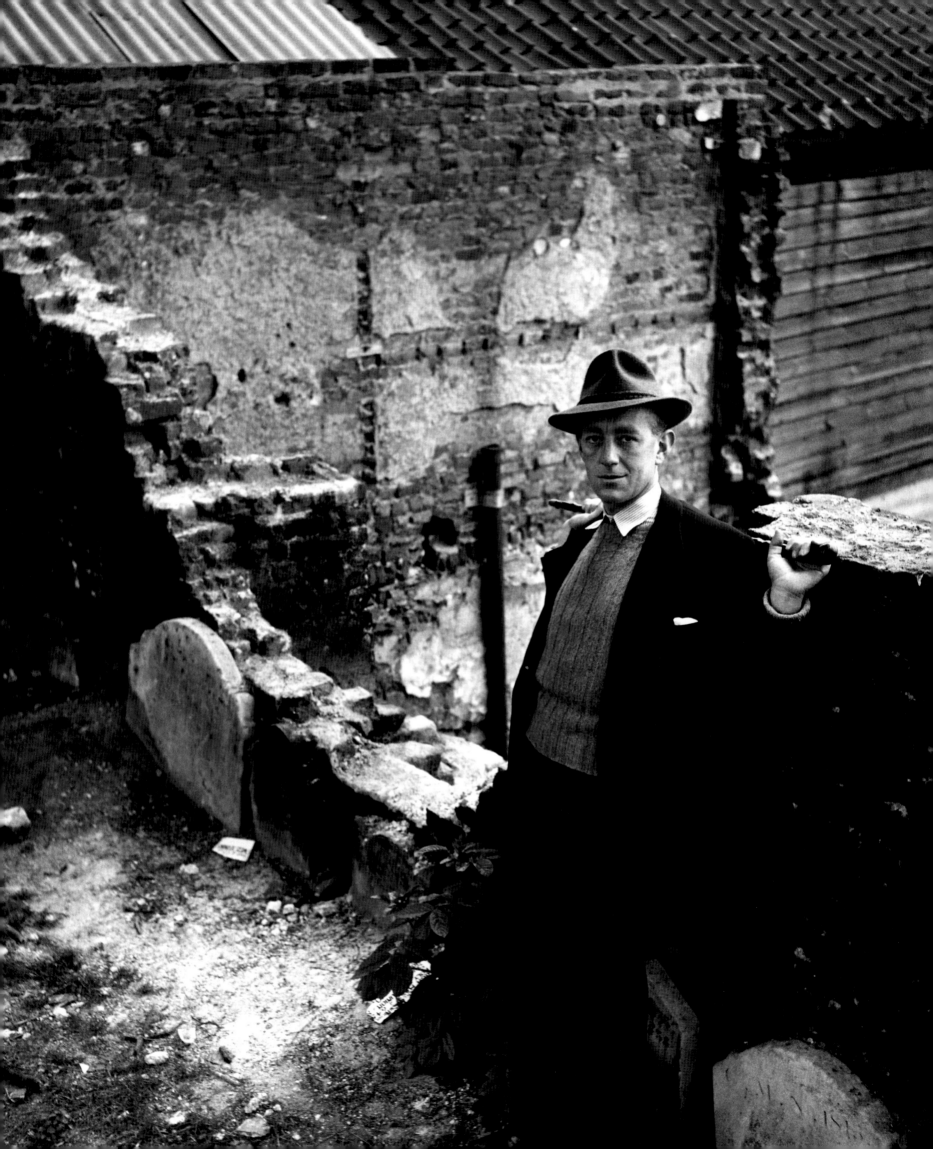

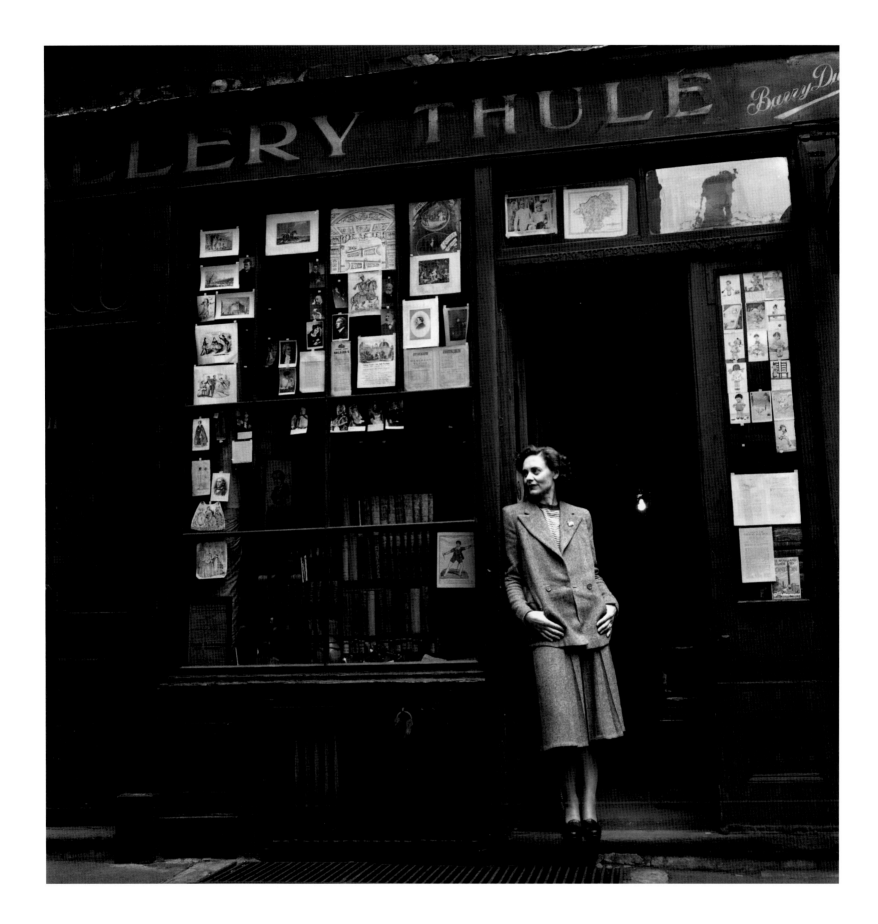

Celia Johnson, London, c. 1950

Alec Guinness, London, c. 1950

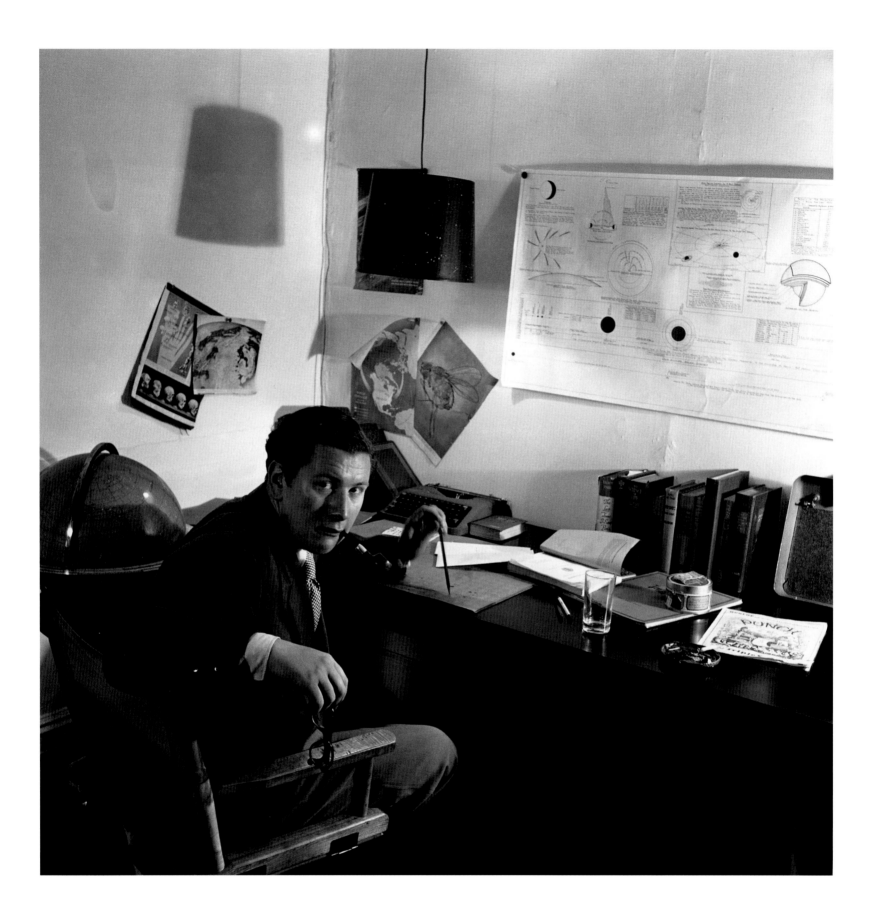

Peter Ustinov while directing his play *The Love of Four Colonels* on Broadway, 1953

David Lean outside his mews studio, London, c. 1950

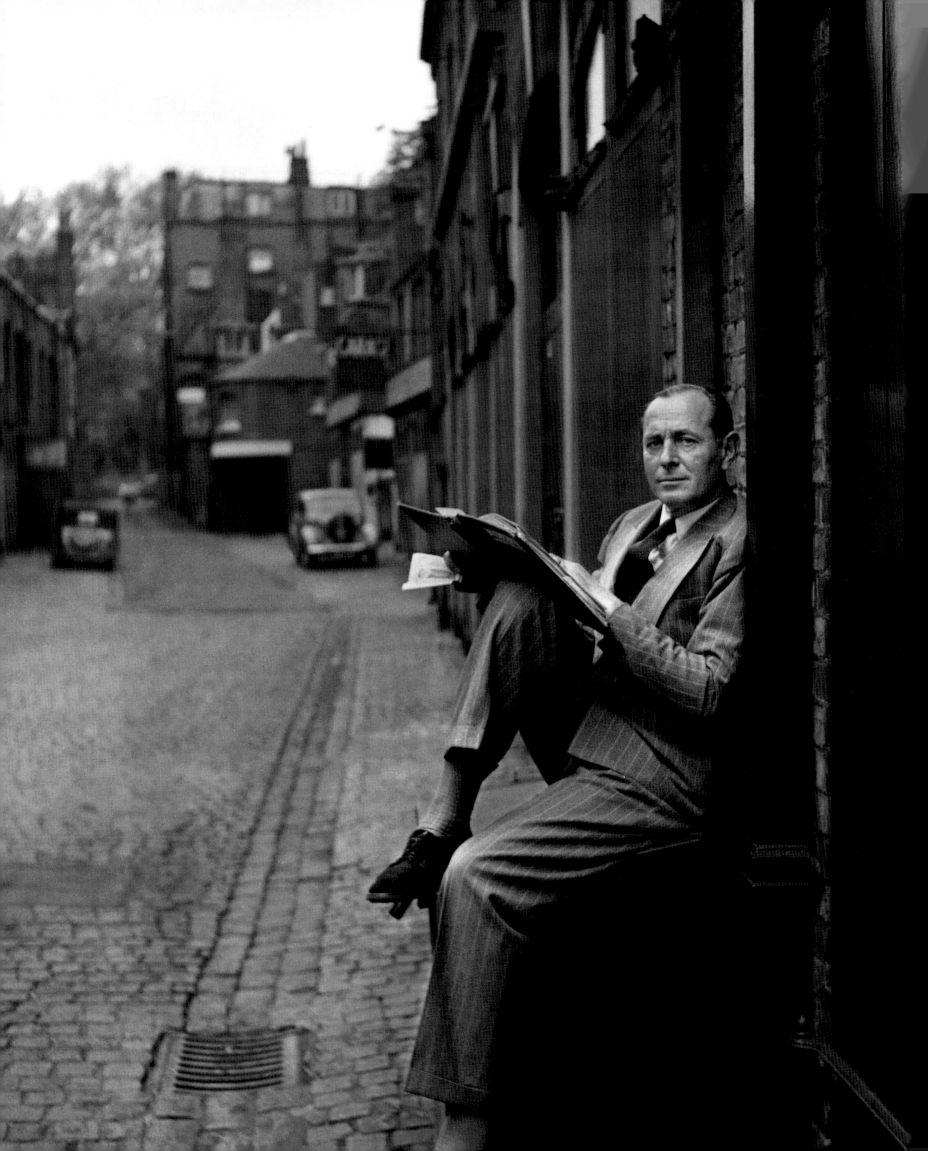

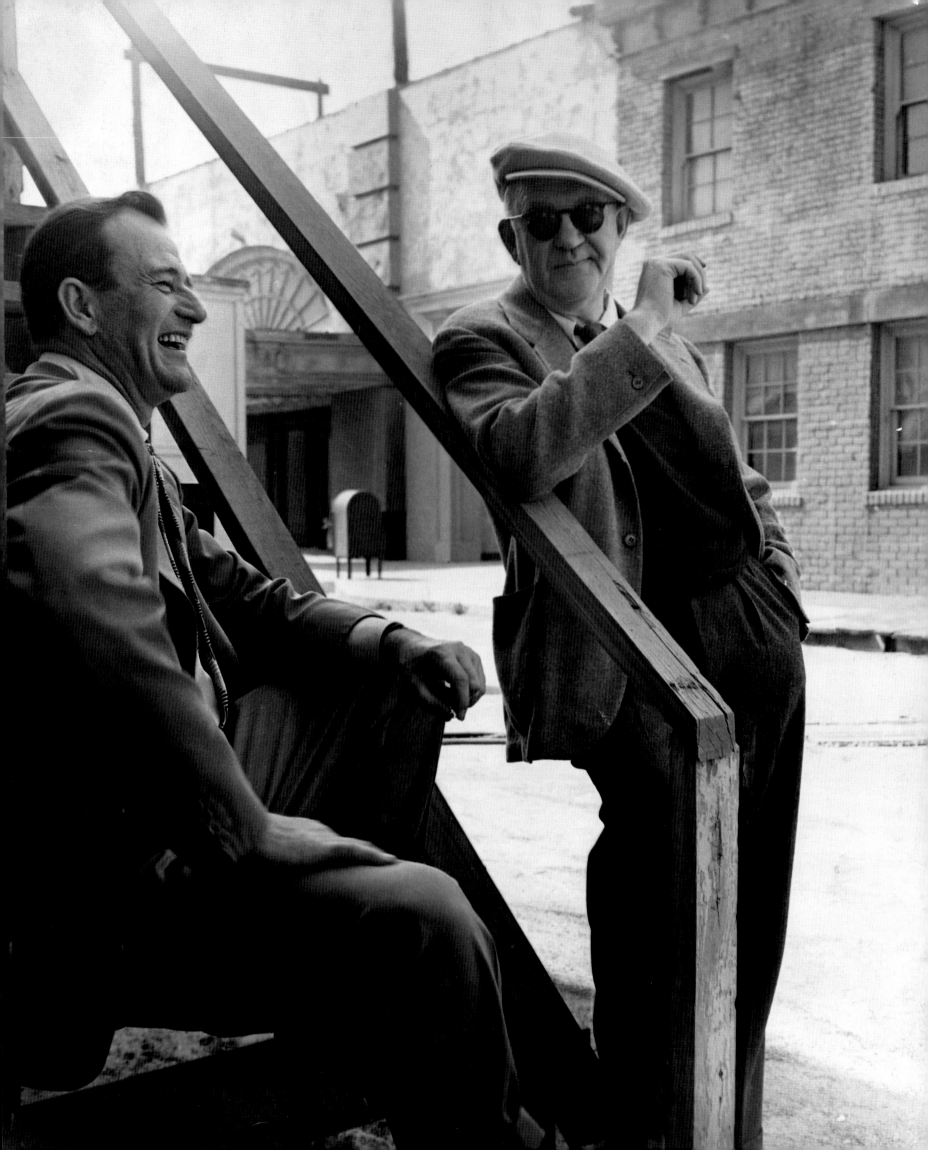

Gary Cooper, Brentwood, California, 1950

John Wayne and John Ford, Hollywood, 1950

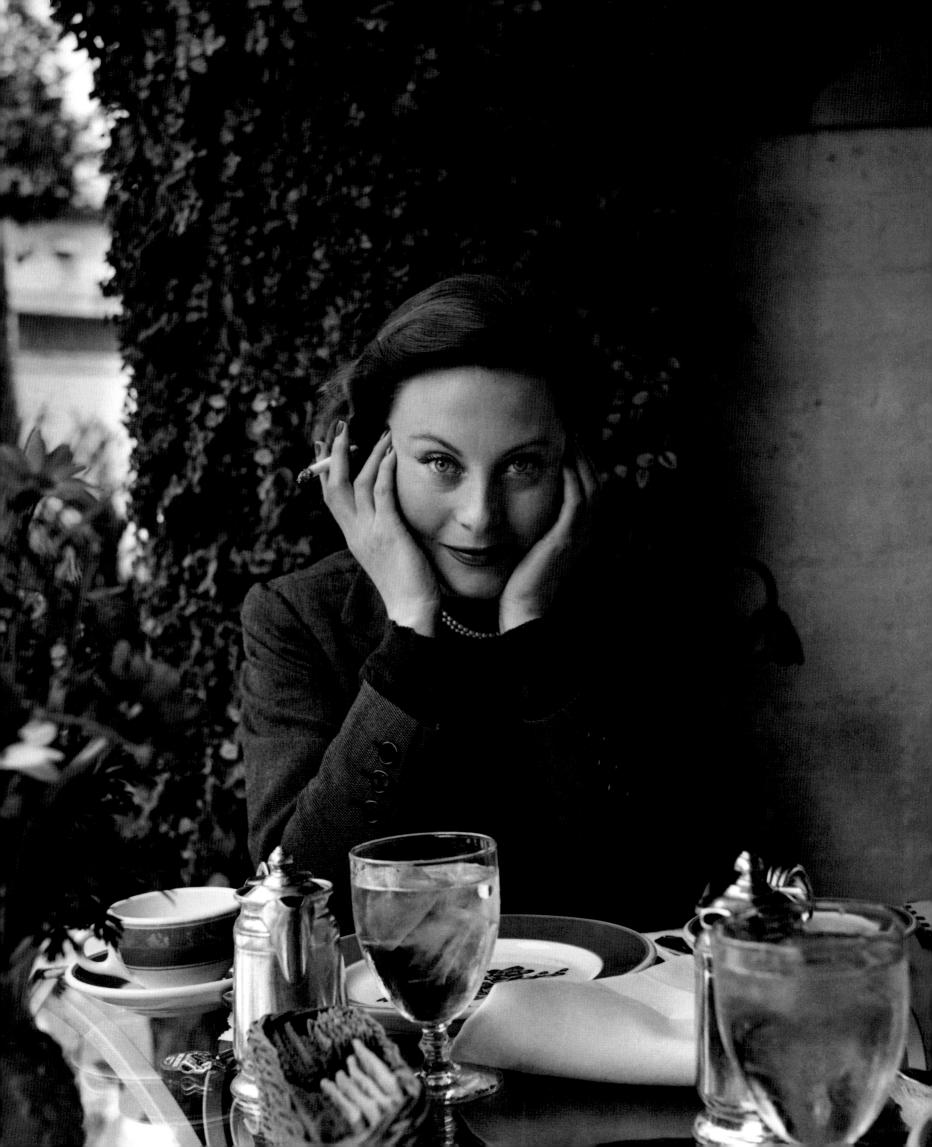

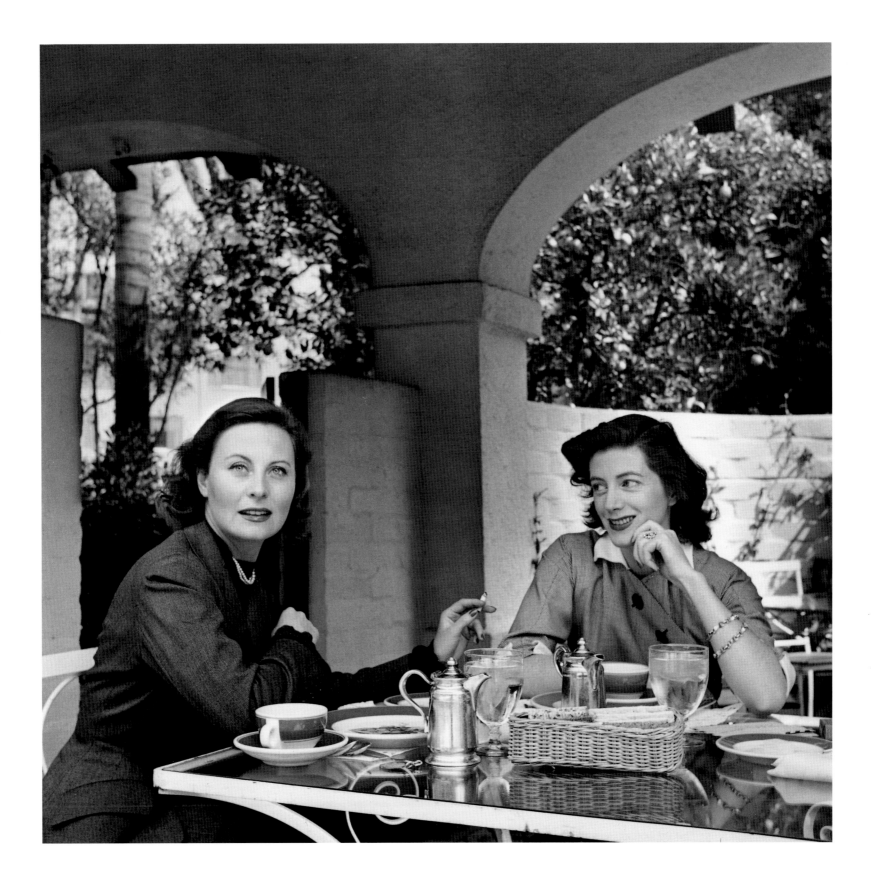

Michèle Morgan, and with Sarah Churchill, Hollywood, c. 1950

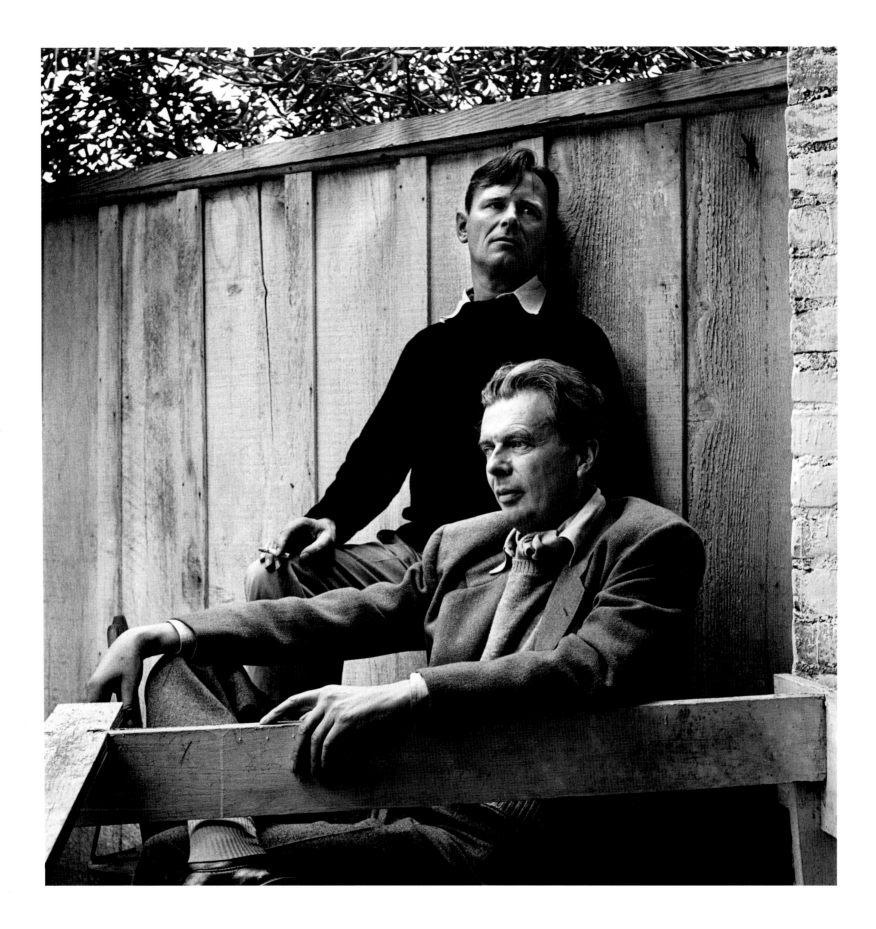

Christopher Isherwood and Aldous Huxley, Santa Monica, California, c. 1950

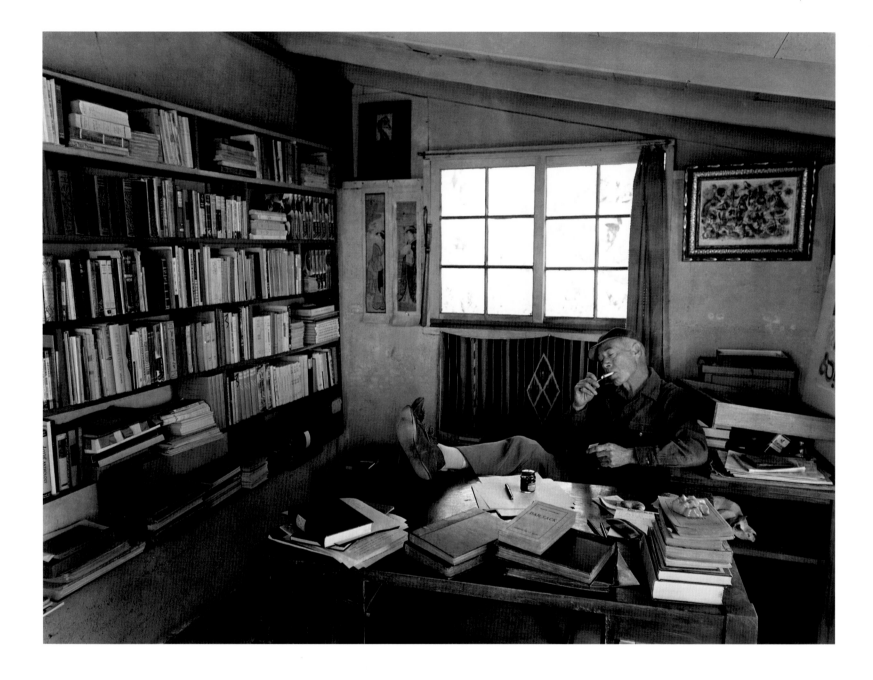

Henry Miller, Big Sur, California, 1950

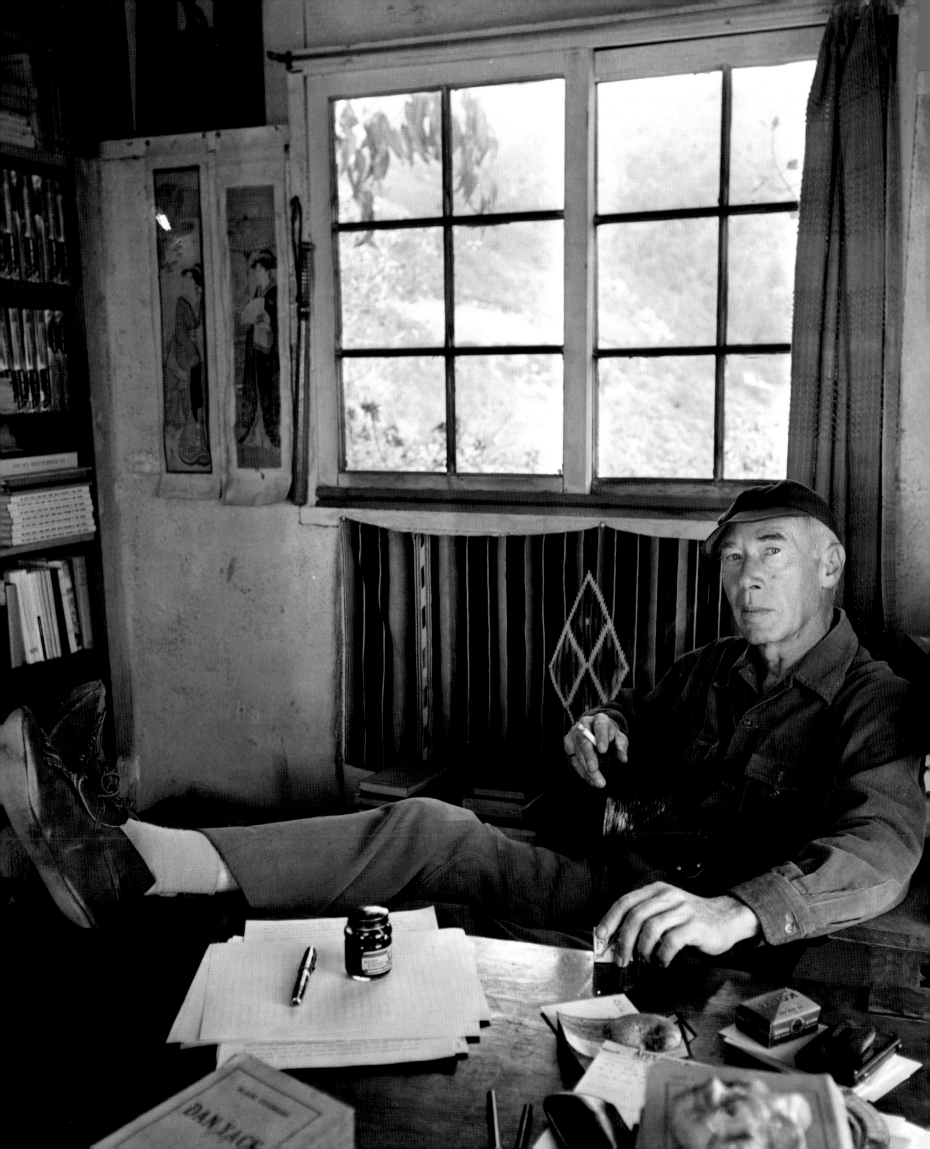

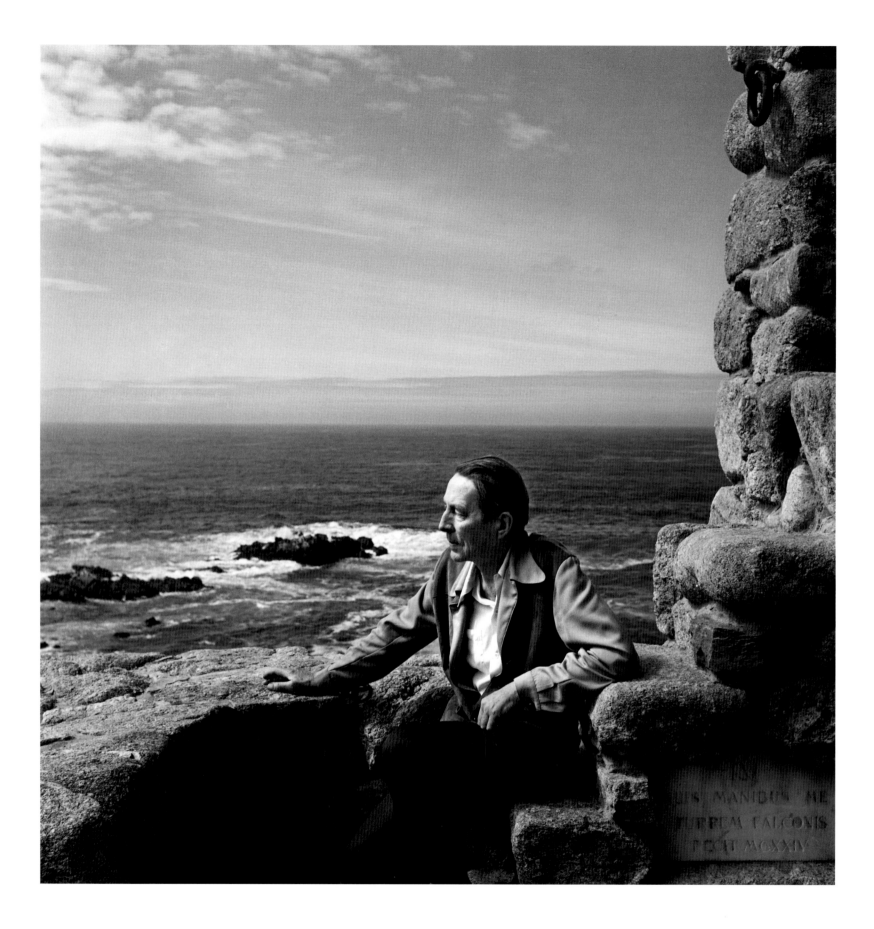

Robinson Jeffers at Hawk Tower, Carmel, California, 1950

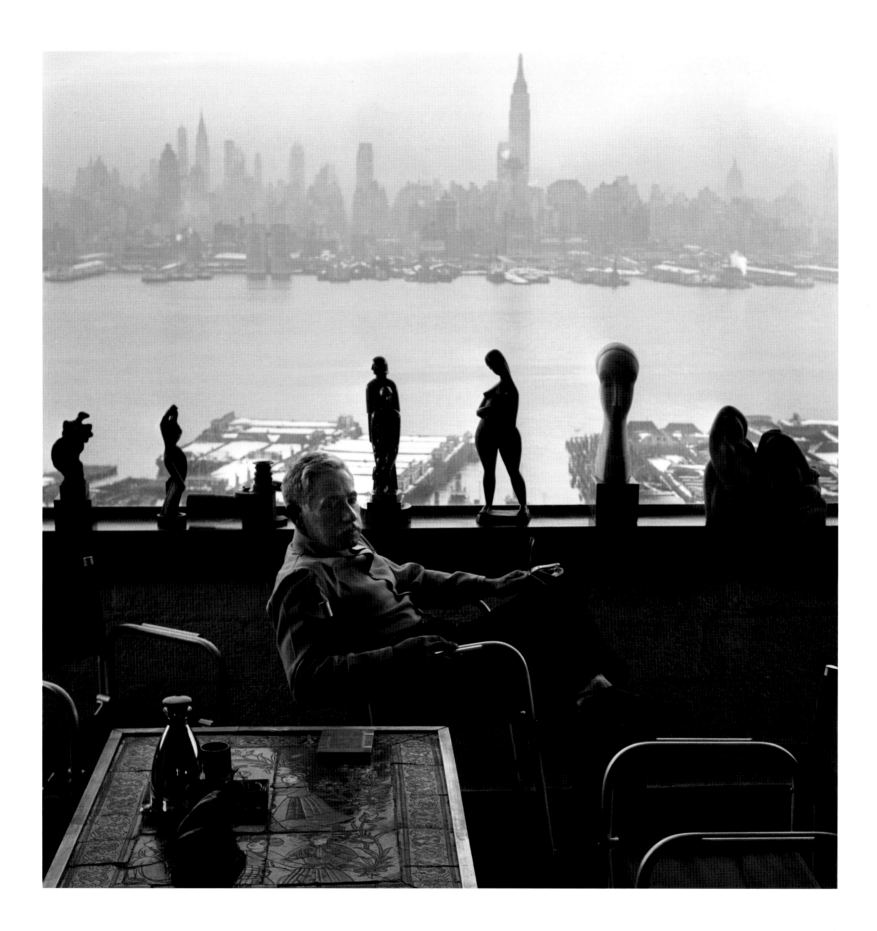

Joseph von Sternberg, Fort Lee, New Jersey, early 1950s

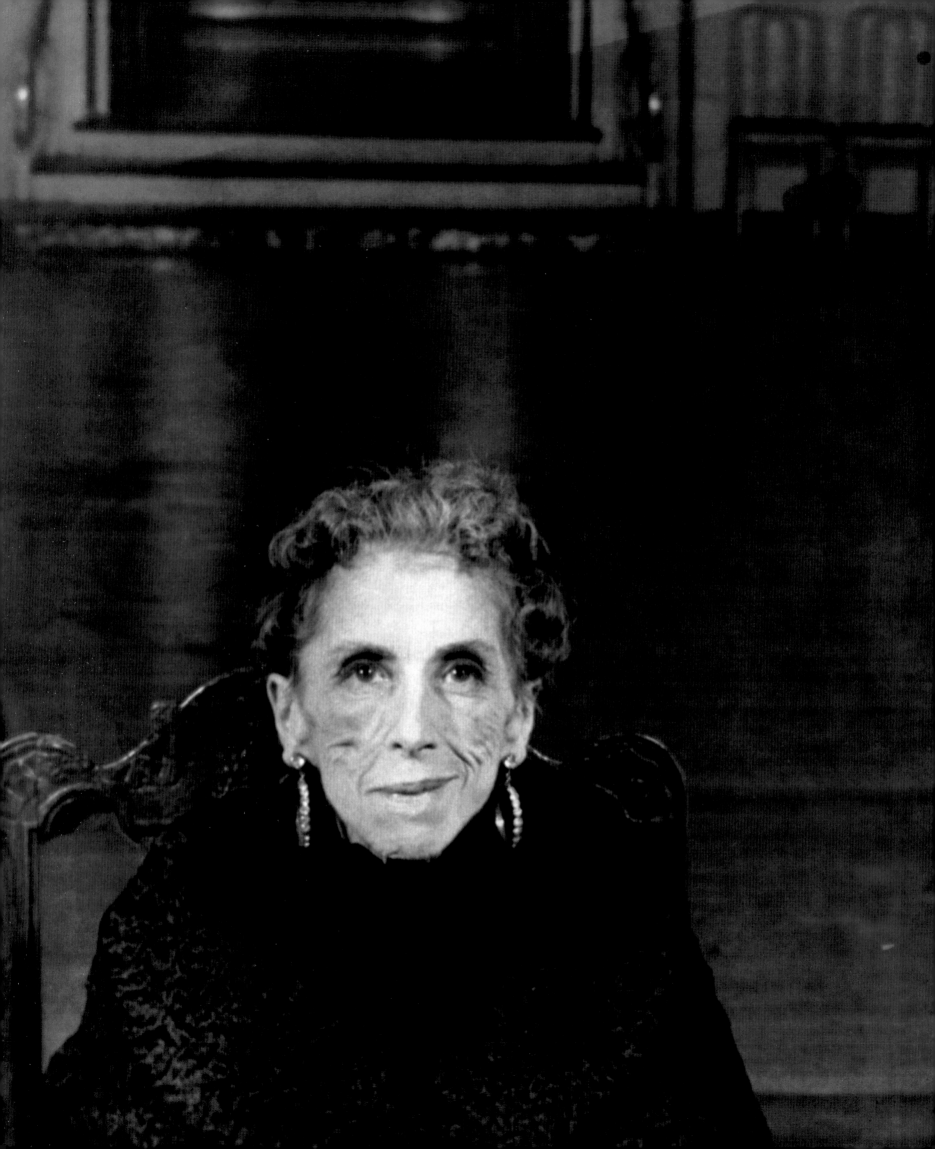

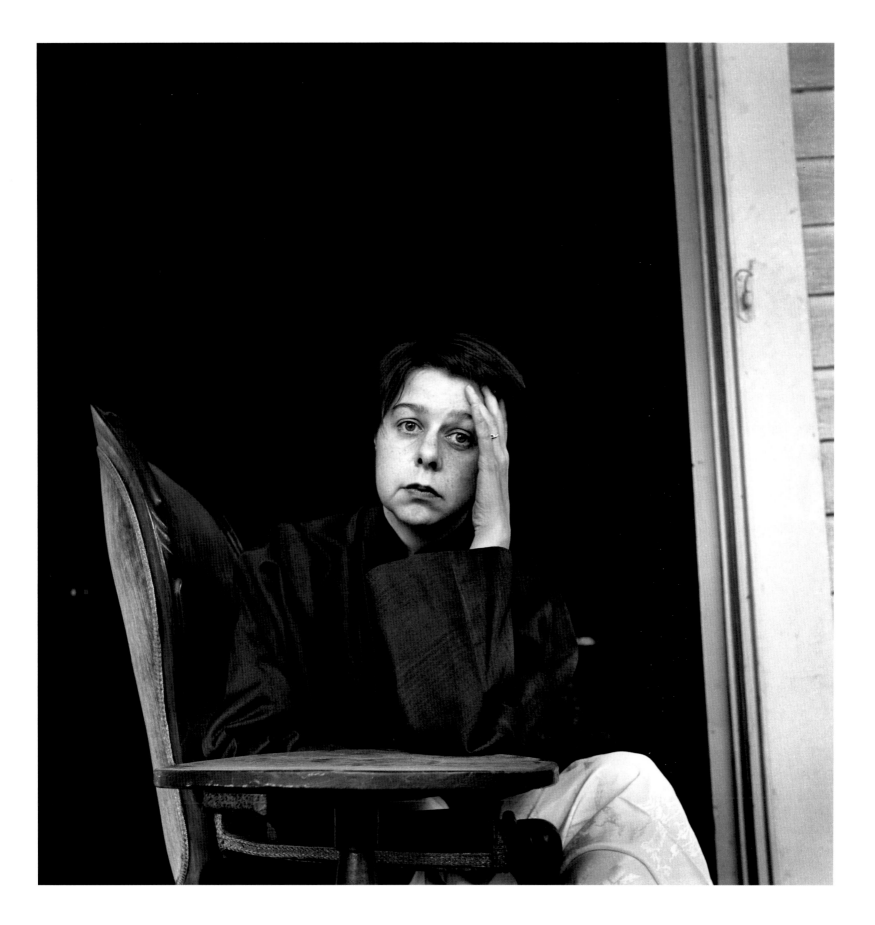

Carson McCullers, Nyack, New York, c. 1950

Isak Dinesen, New York, c. 1950

Tennessee Williams, 1948

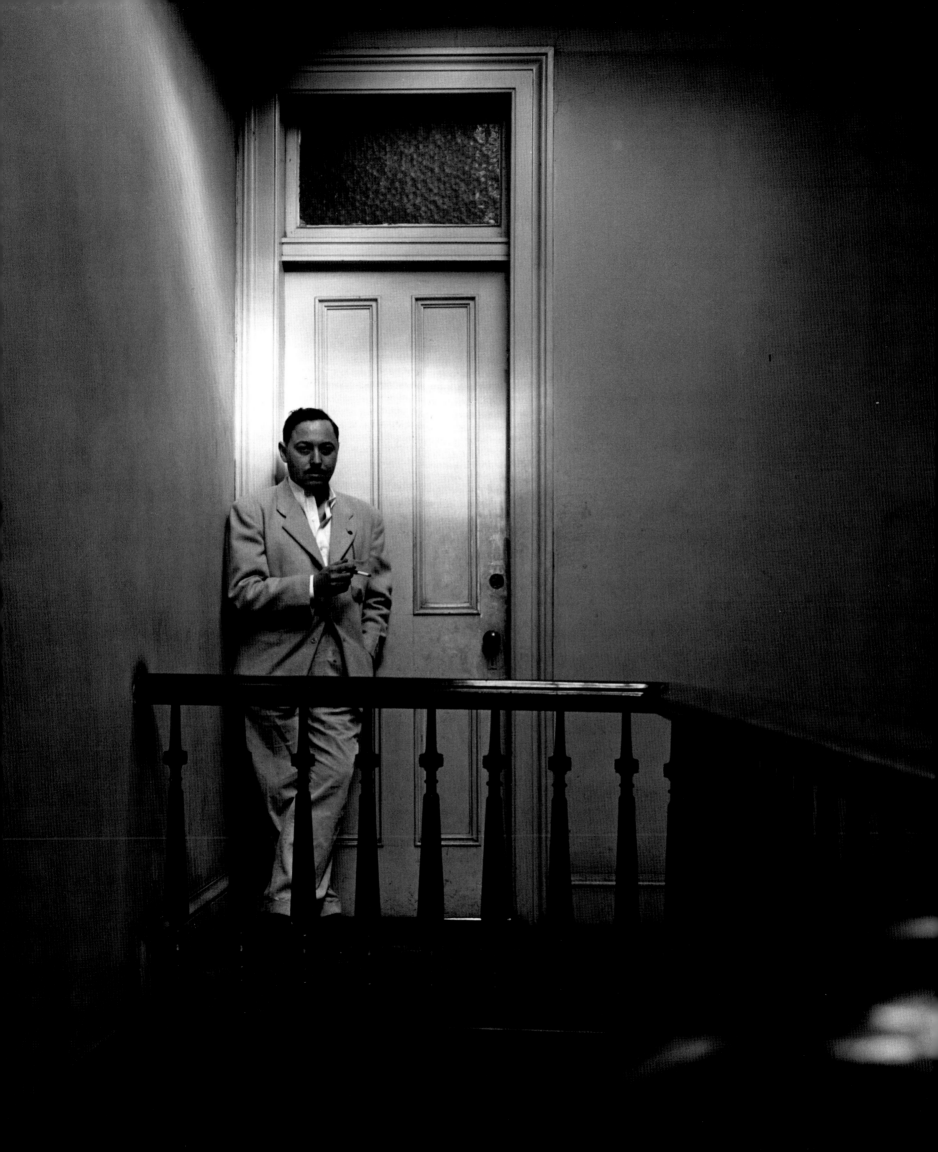

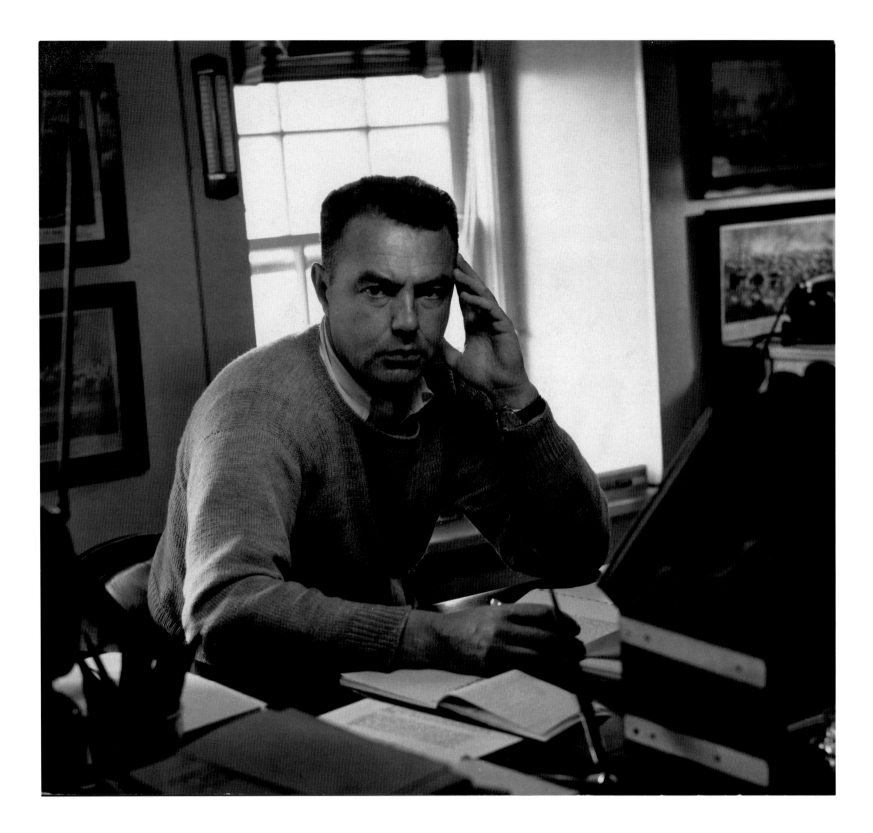

James Gould Cozzens, early 1950s

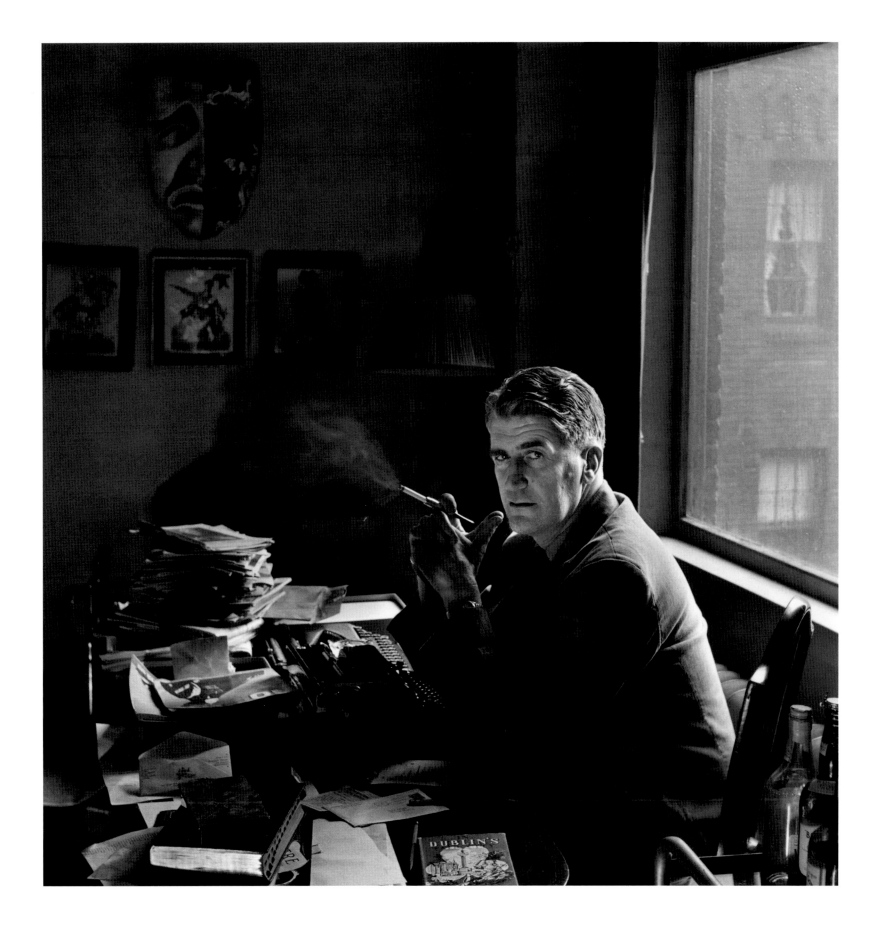

Denis Johnston in New York for the production of his play *The Old Lady Says "No!"*, 1948

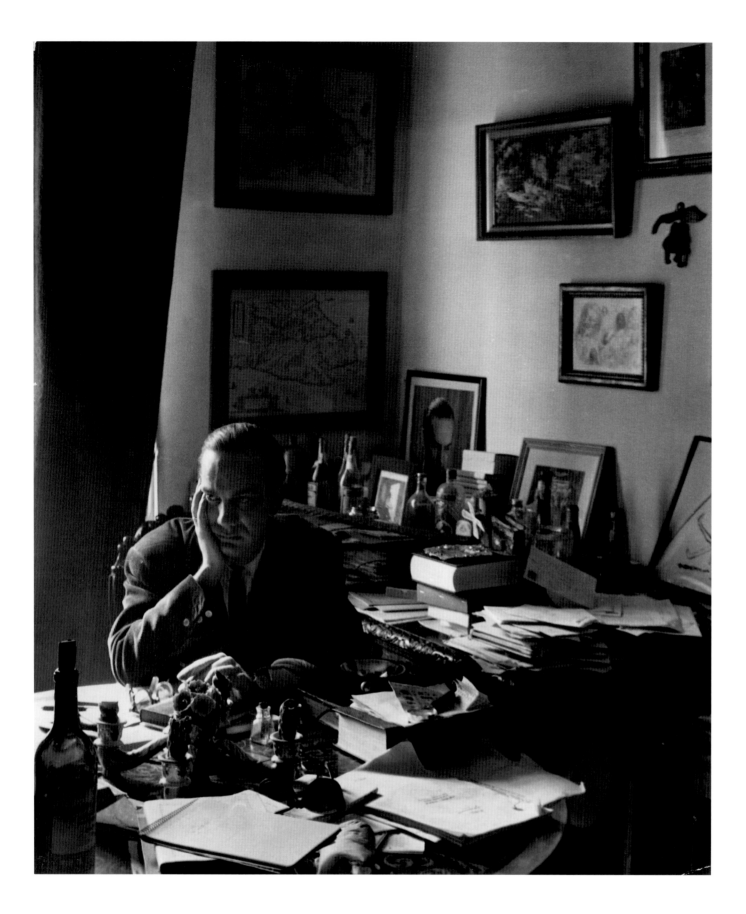

Camilo José Cela, Madrid, c. 1955

José Ferrer, c. 1950

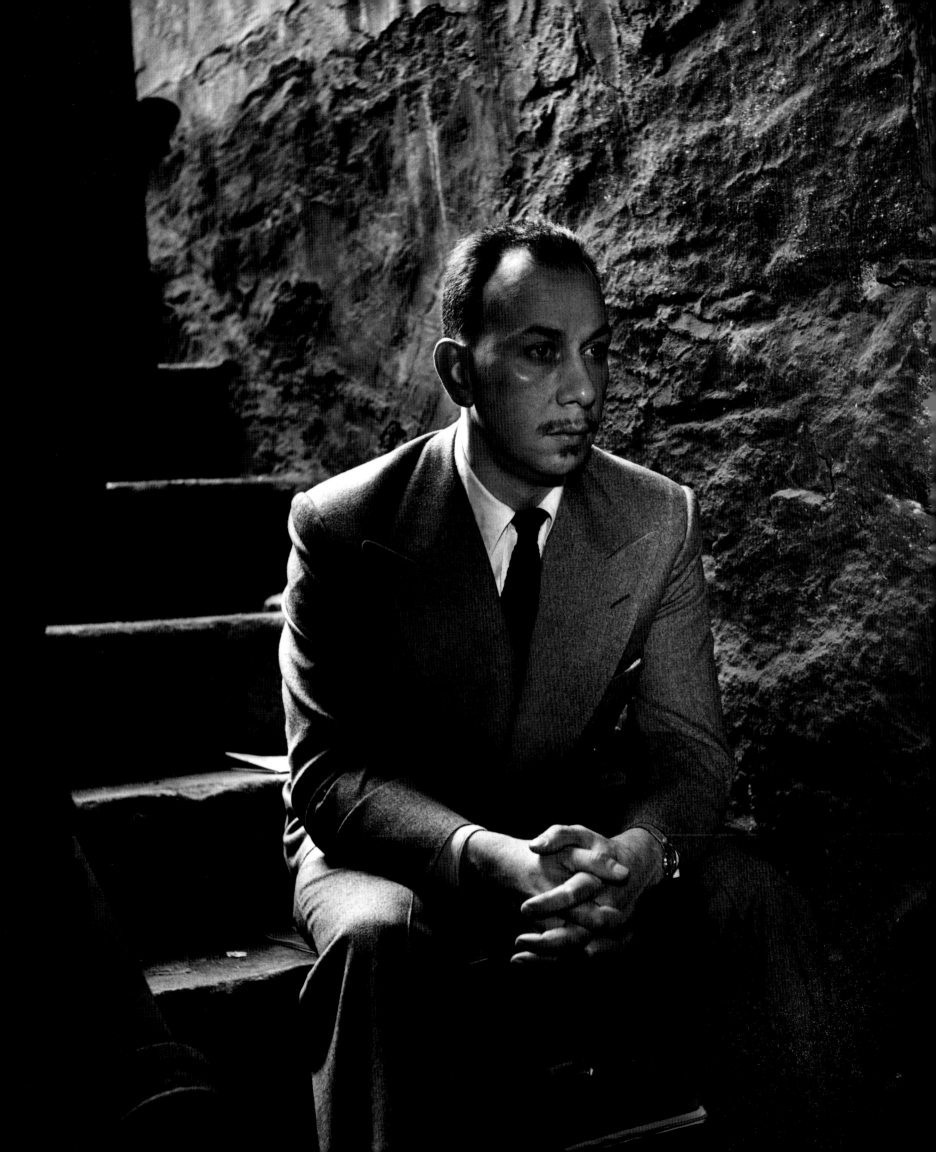

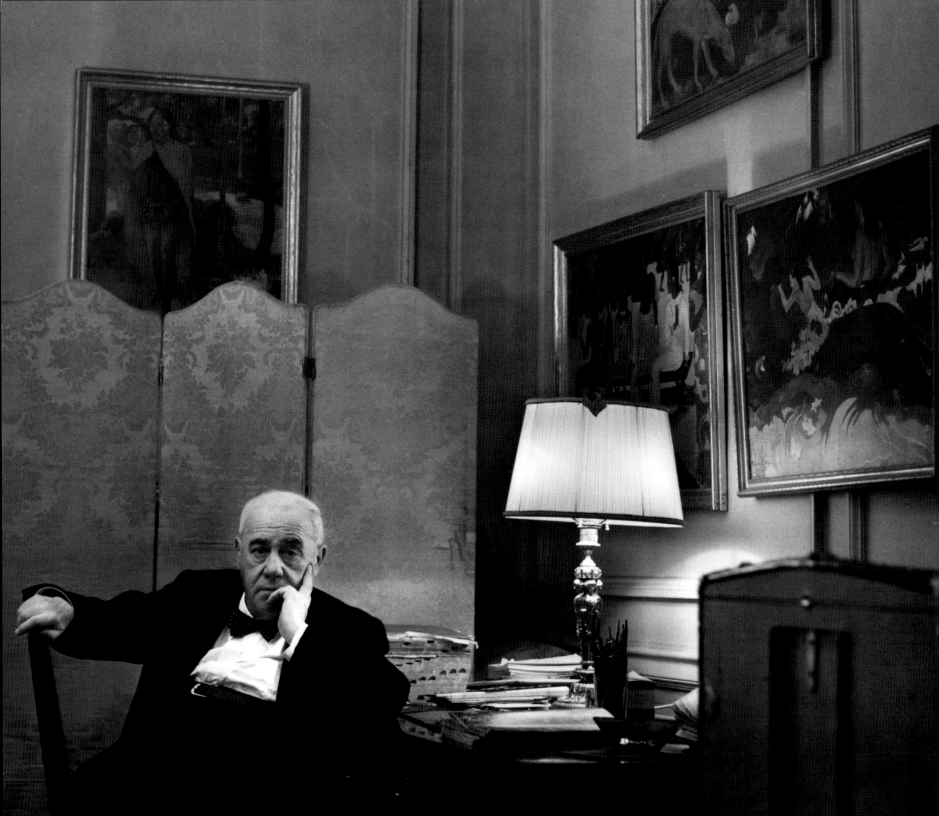

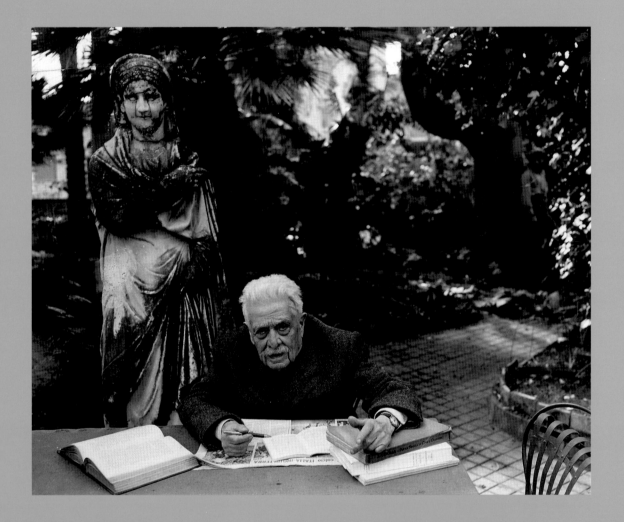

Vittorio Emanuele Orlando, Palermo, 1949

Ferenc Molnár, Plaza Hotel, New York, early 1950s

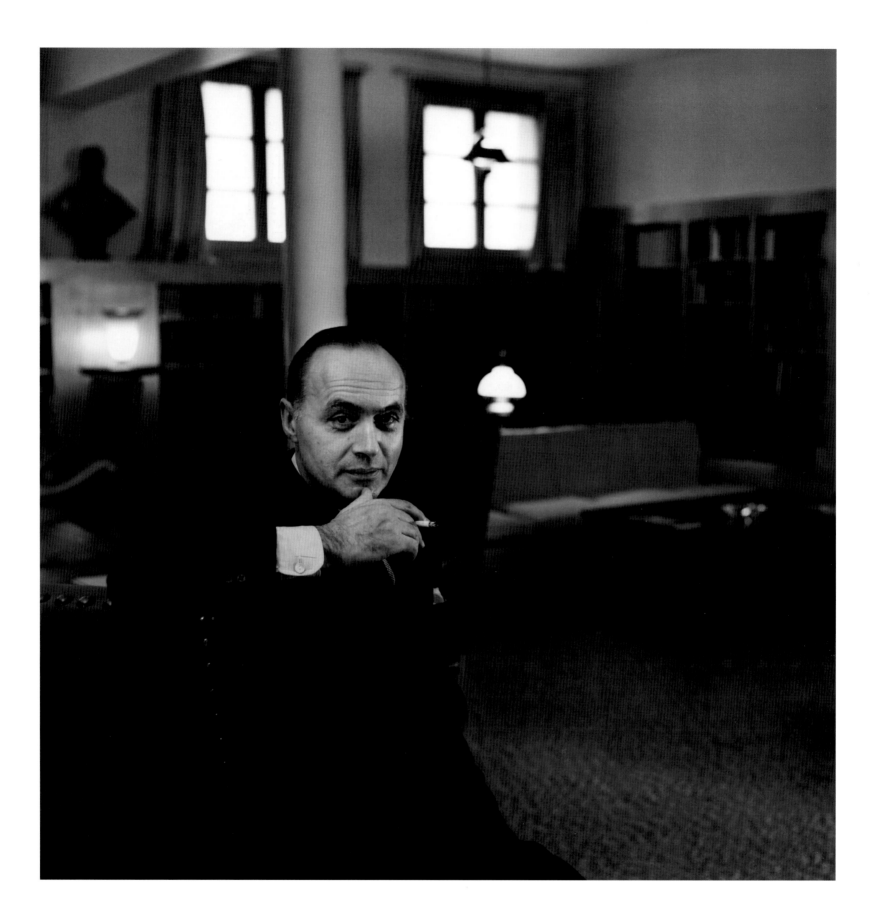

Charles Boyer in the library of the French Research Foundation in California,
which he established to promote French-American relations, 1953

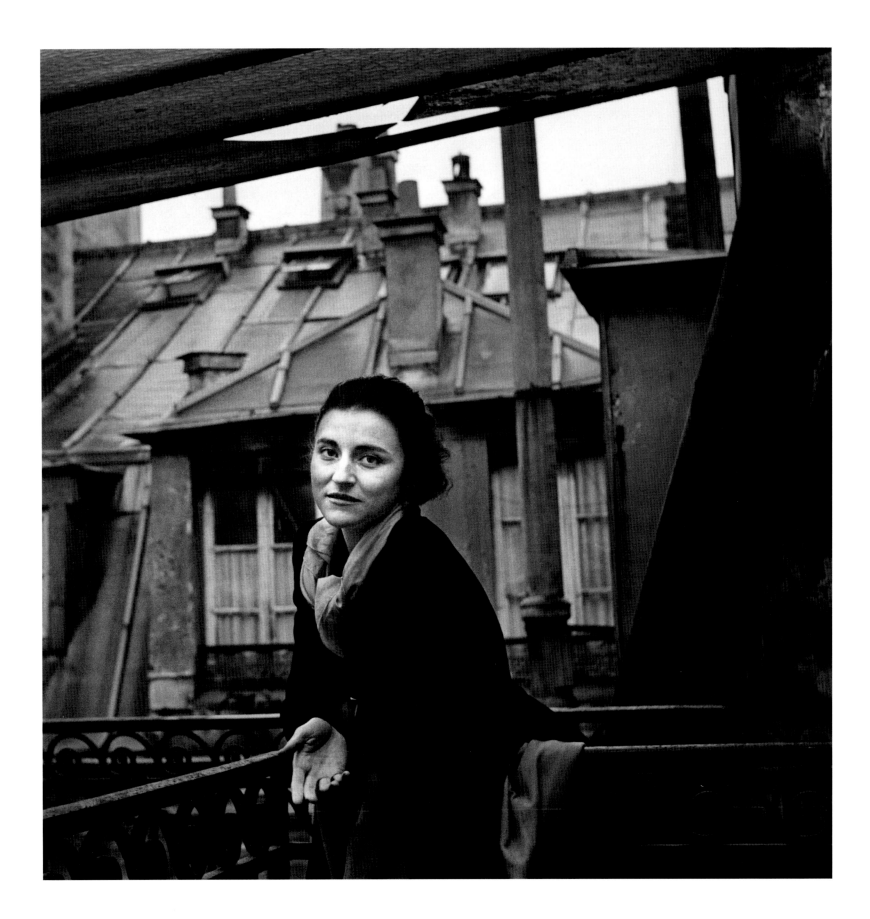

Theodora Roosevelt Keogh, Paris, 1948

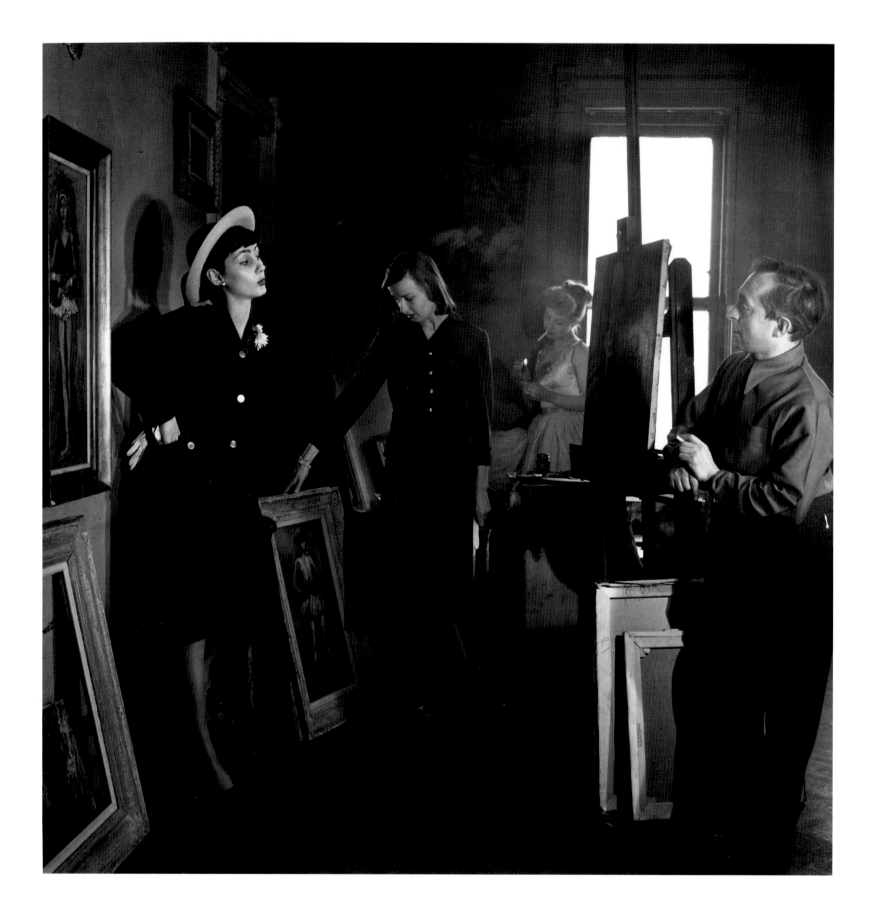

Raphael Soyer, c. 1949

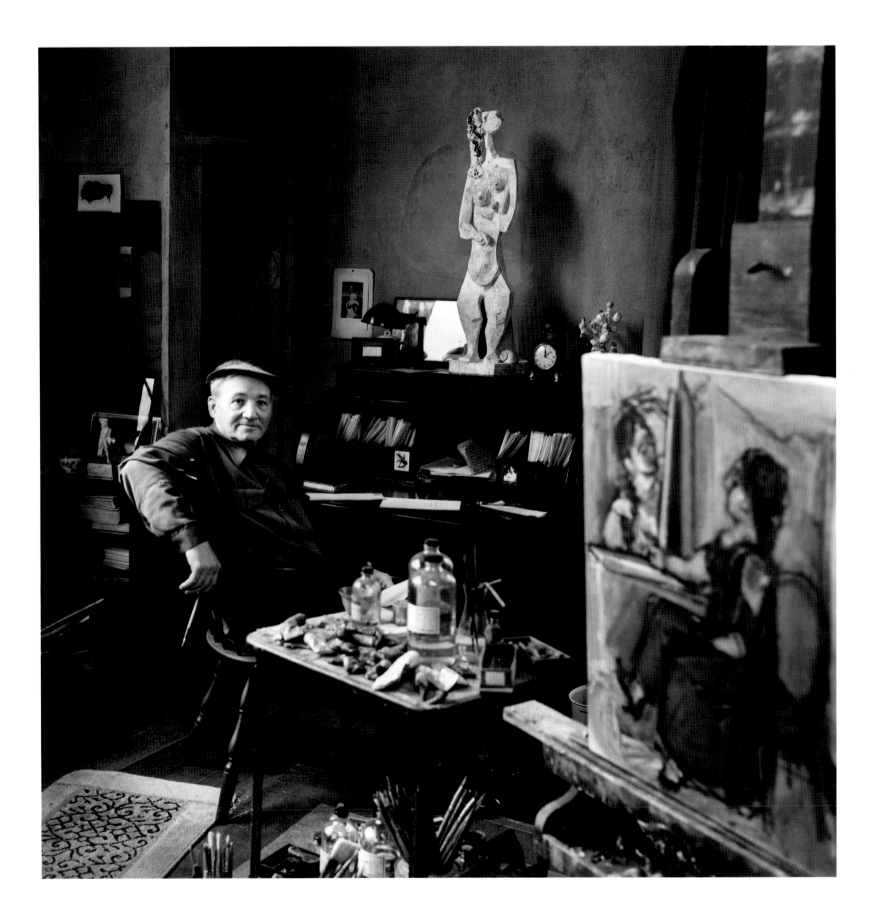

Max Weber, Great Neck, Long Island, 1950

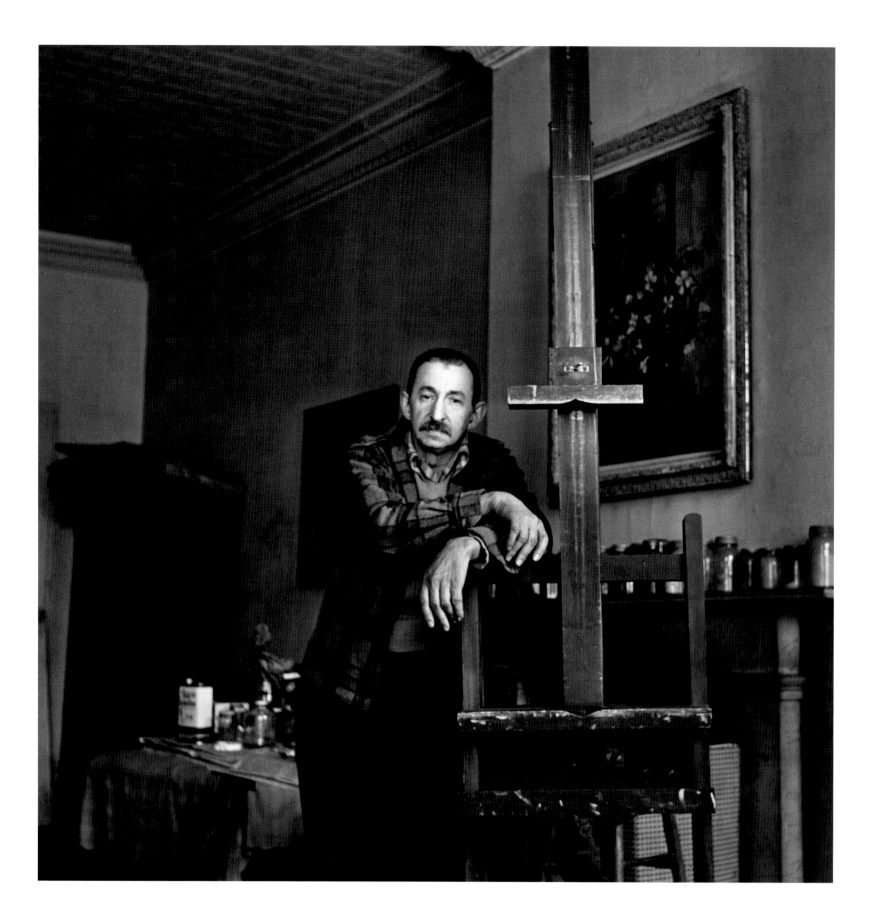

Morris Kantor in his Union Square studio, early 1950s

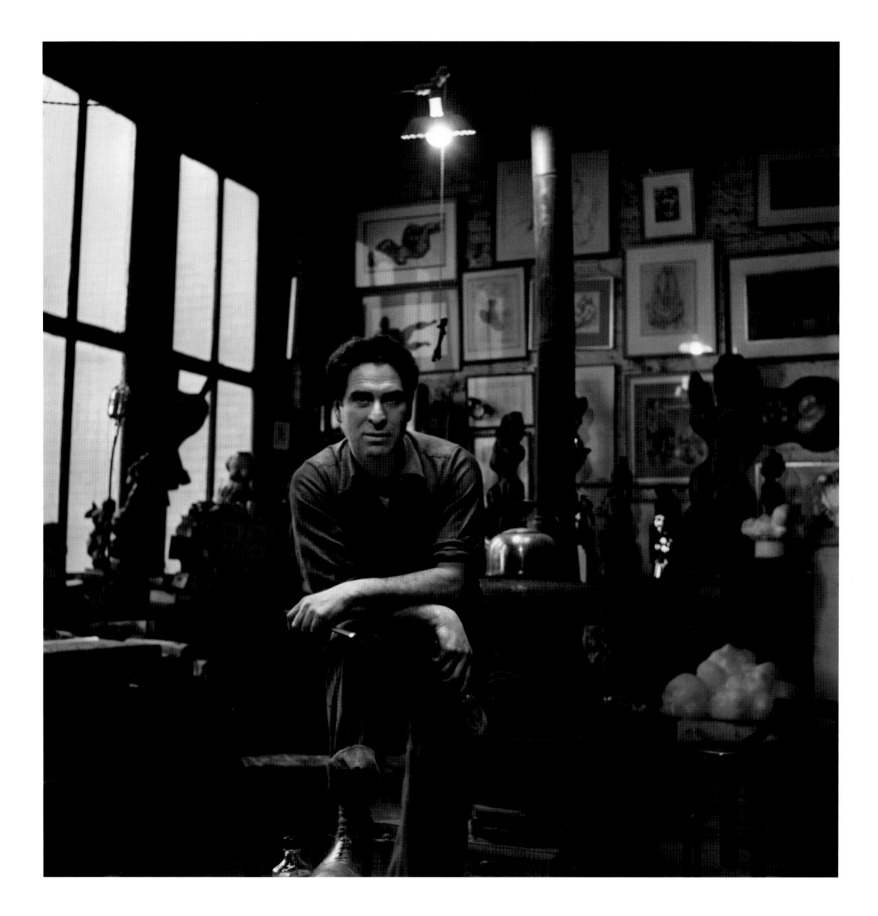

Chaim Gross, 1951

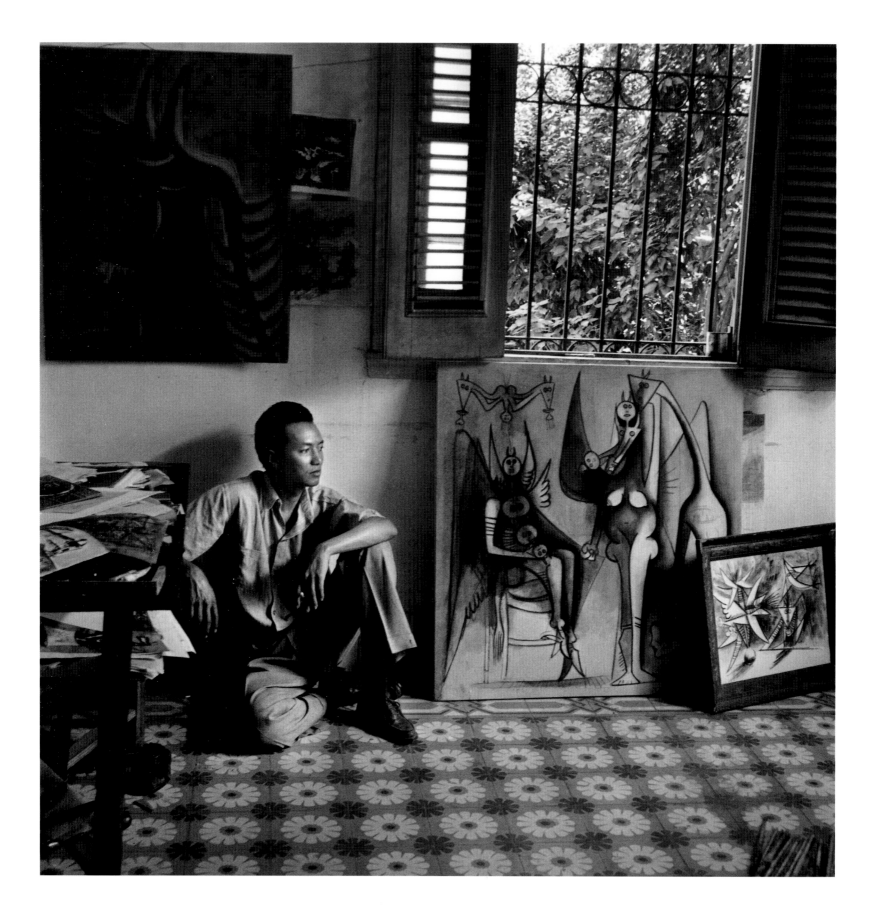

Wilfredo Lam, Havana, Cuba, 1948

94

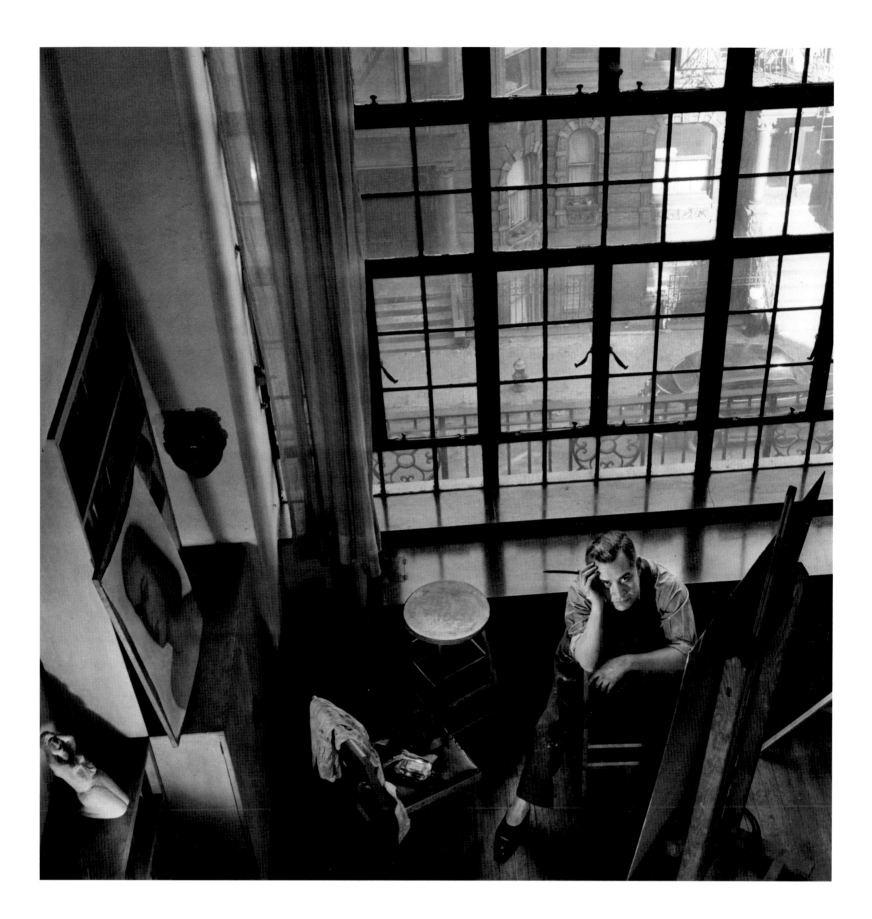

Rufino Tamayo, New York, c. 1952

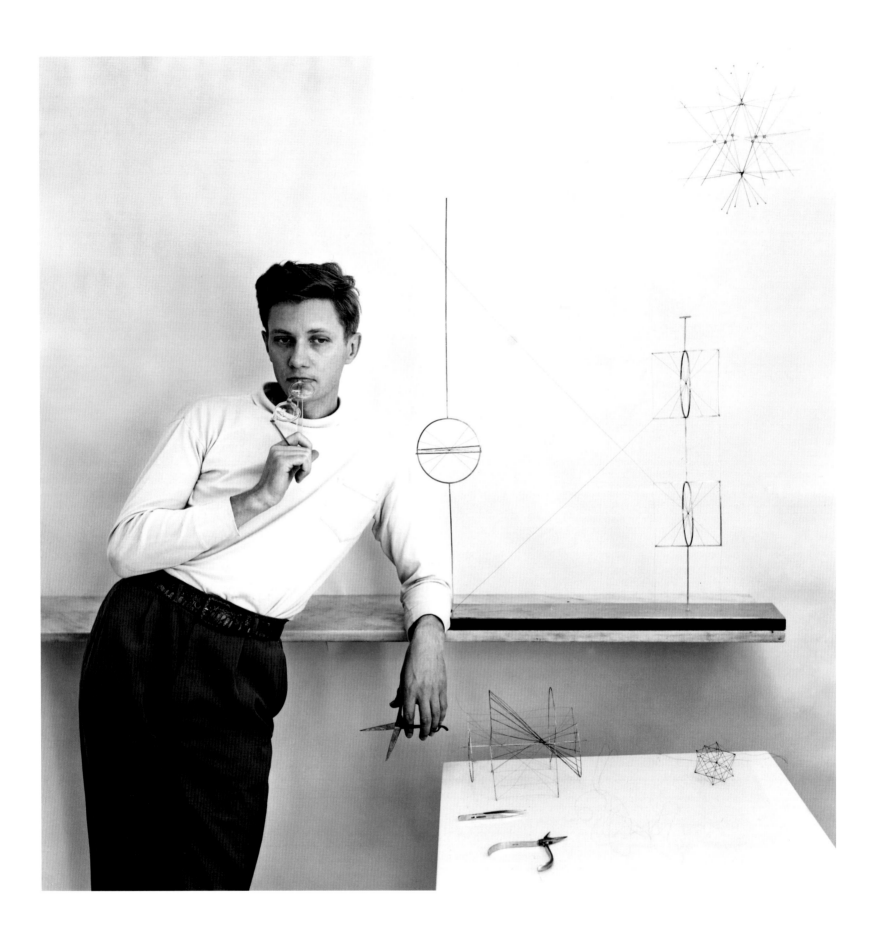

Richard Lippold, 1950

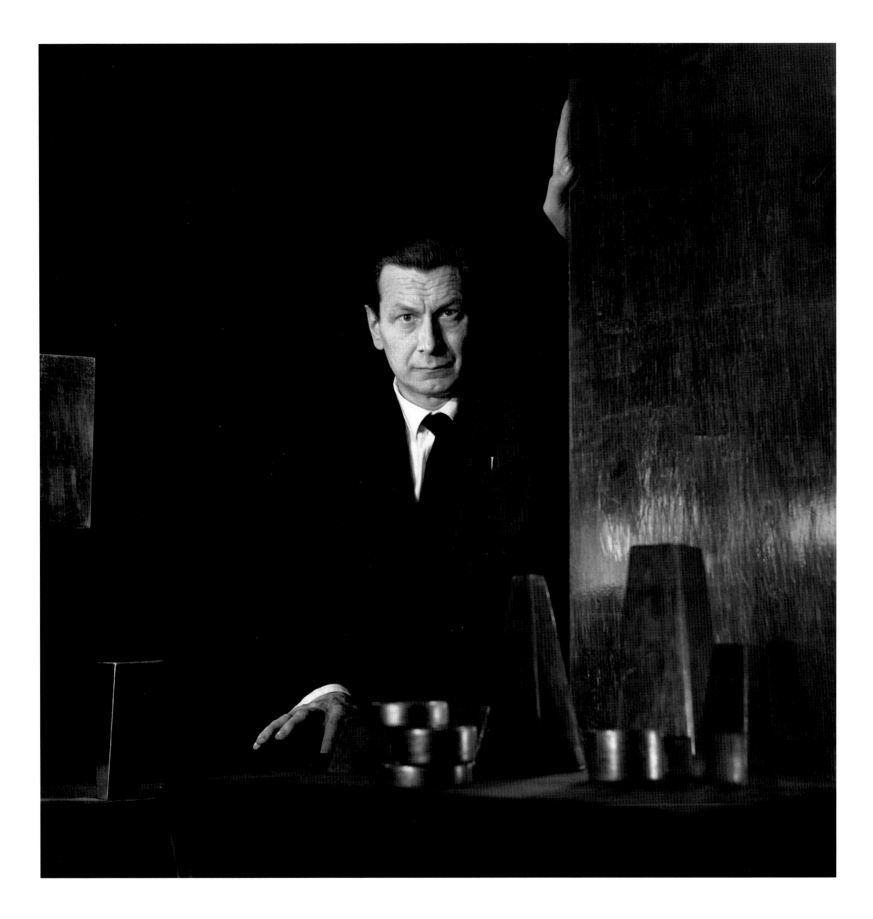

Mathias Goeritz, Mexico City, early 1950s

Saul Steinberg, 1950

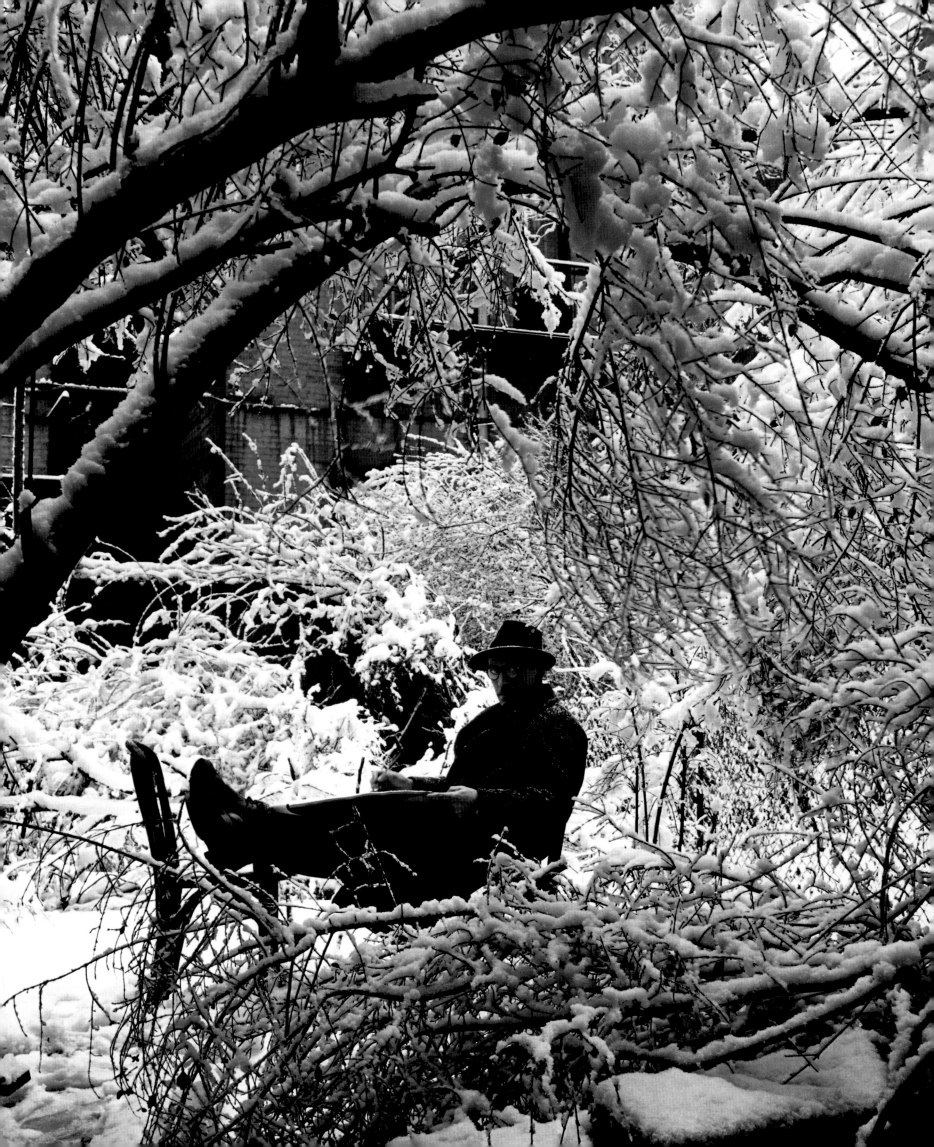

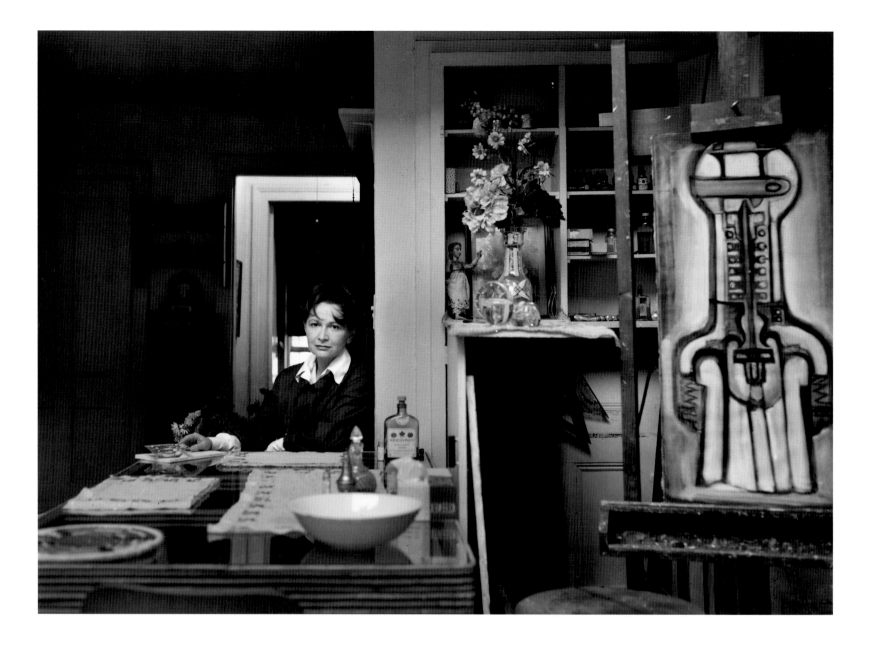

Hedda Sterne, late 1940s

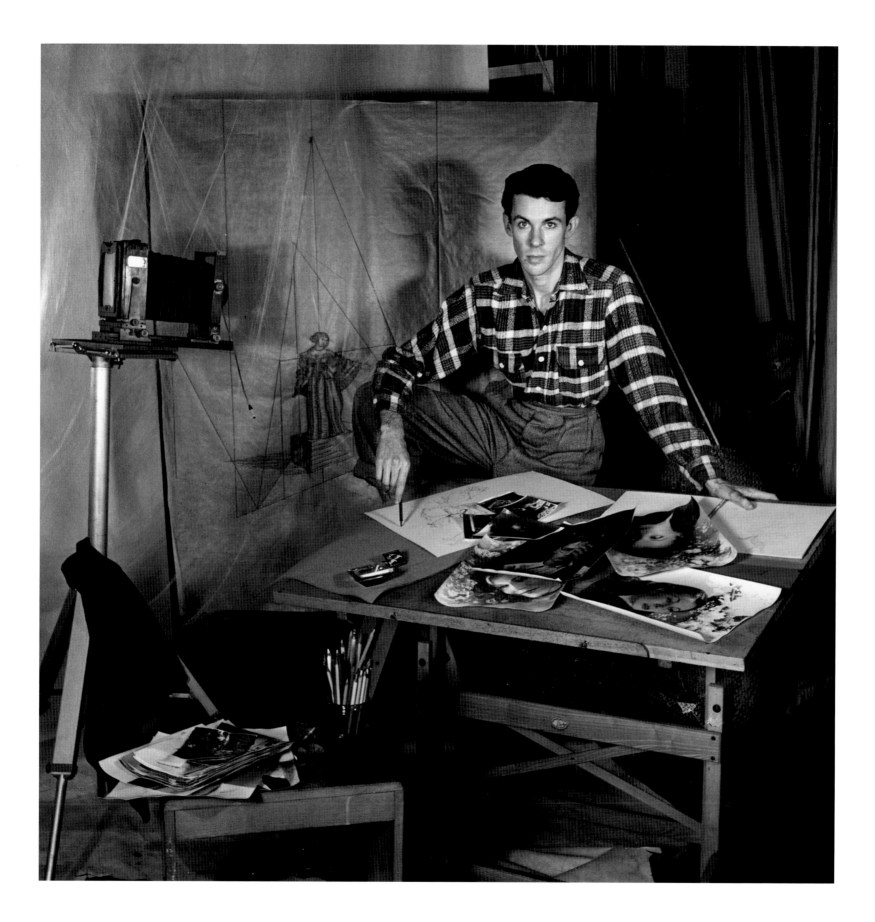

Cris Alexander at the time he was appearing on Broadway in Noel Coward's *Present Laughter*, 1947

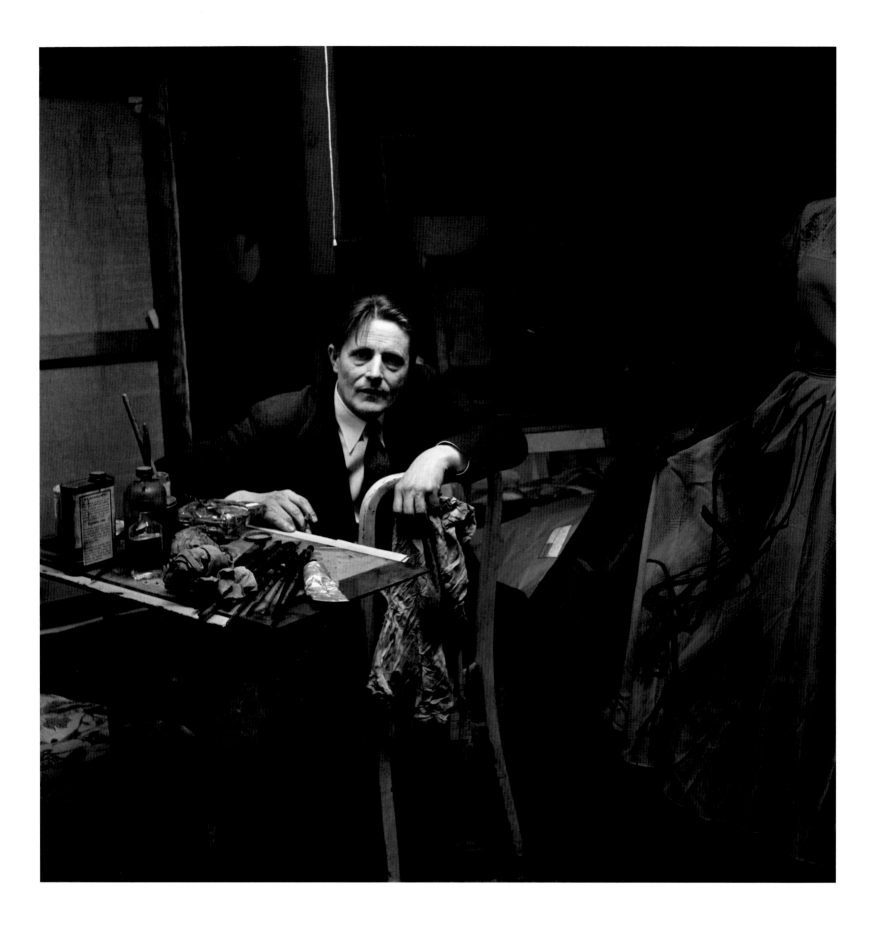

Stanley William Hayter at Atelier 17, Paris, early 1950s

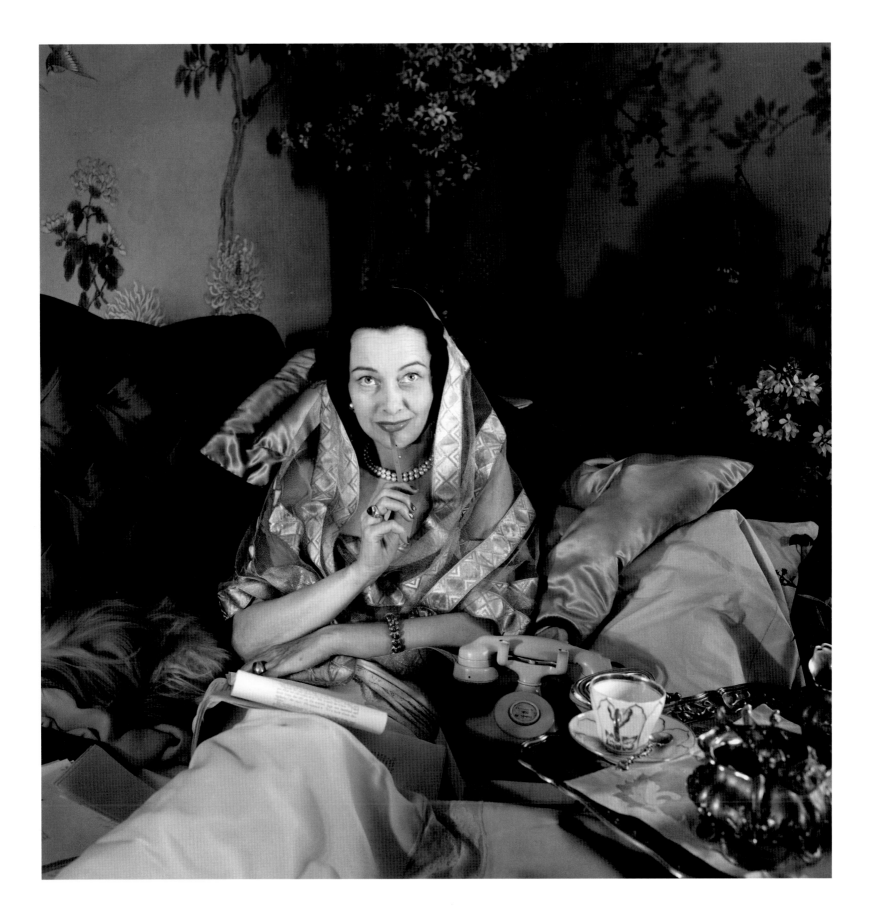

Luli Deste, New York, 1950

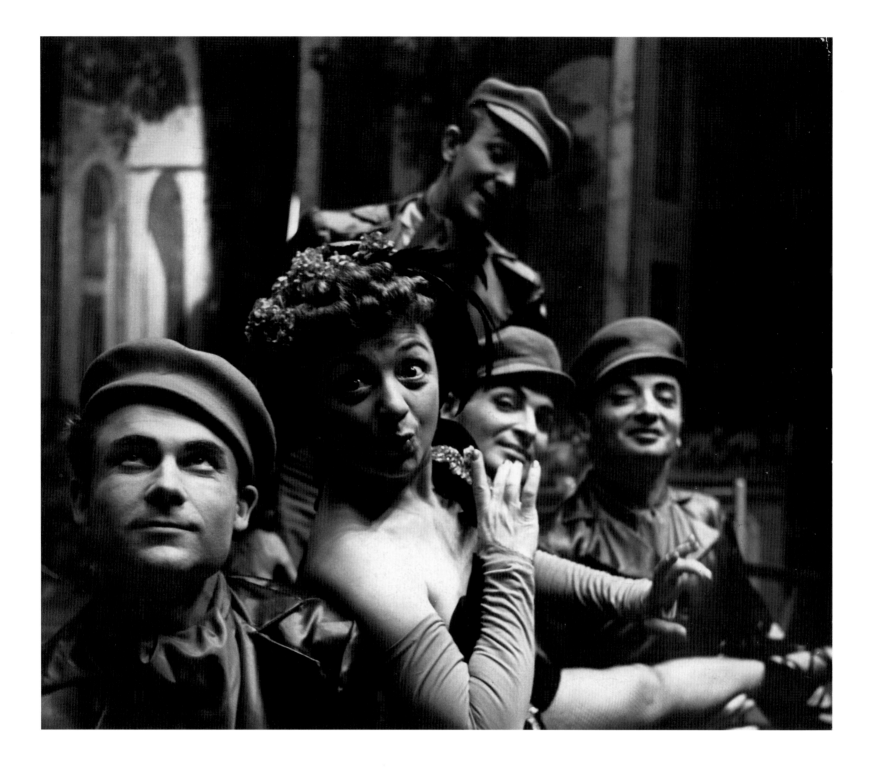

Molly Picon, c. 1950

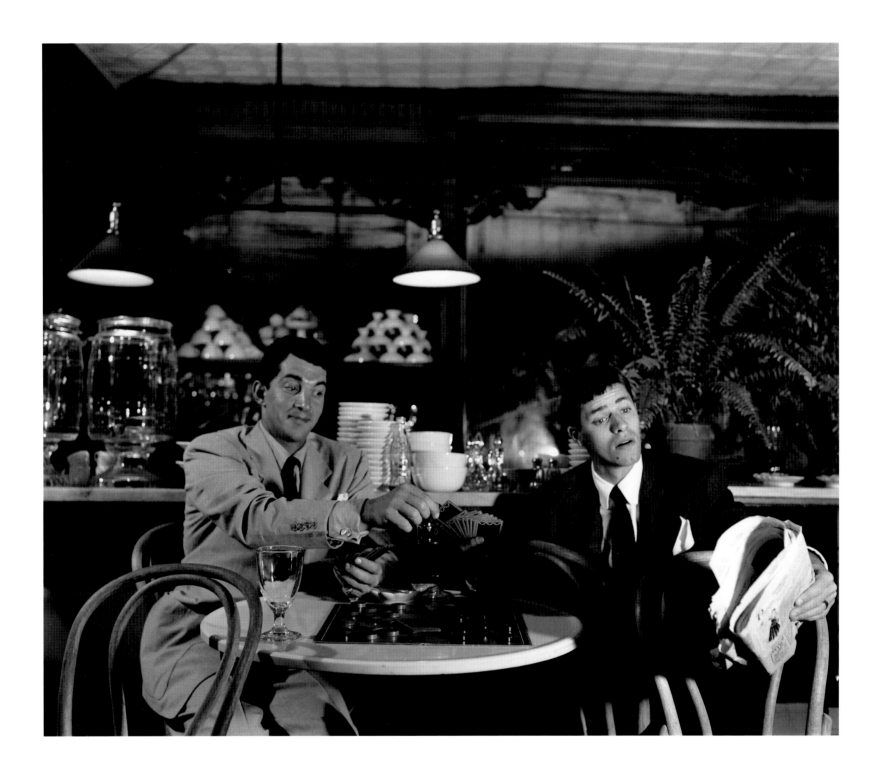

Dean Martin and Jerry Lewis, 1947

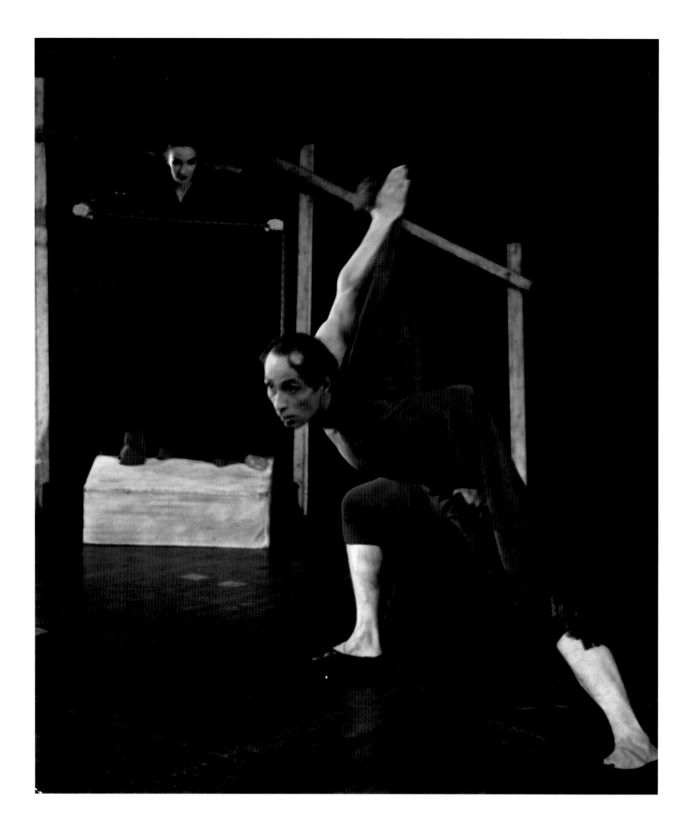

José Greco, Madrid, c. 1951

Agnes de Mille while directing *Allegro* on Broadway, 1947

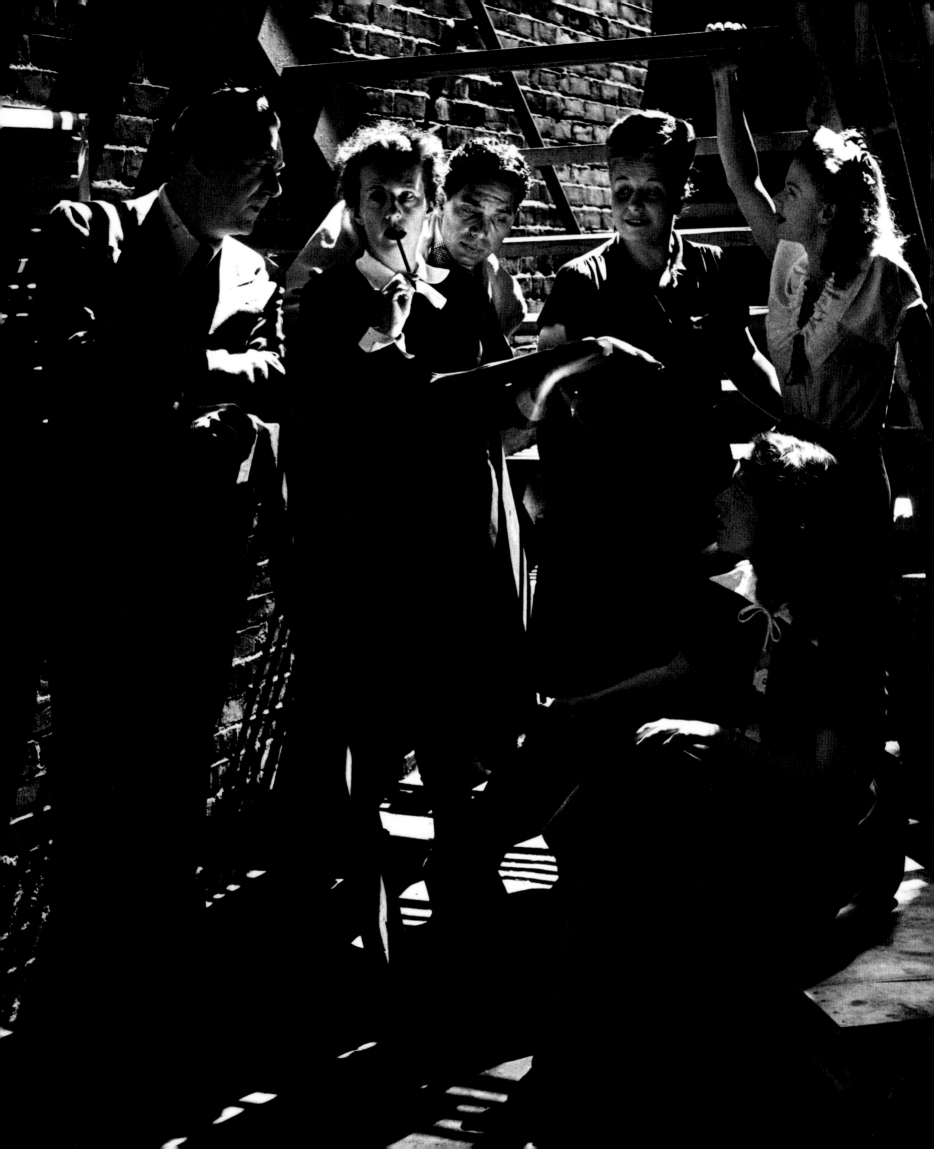

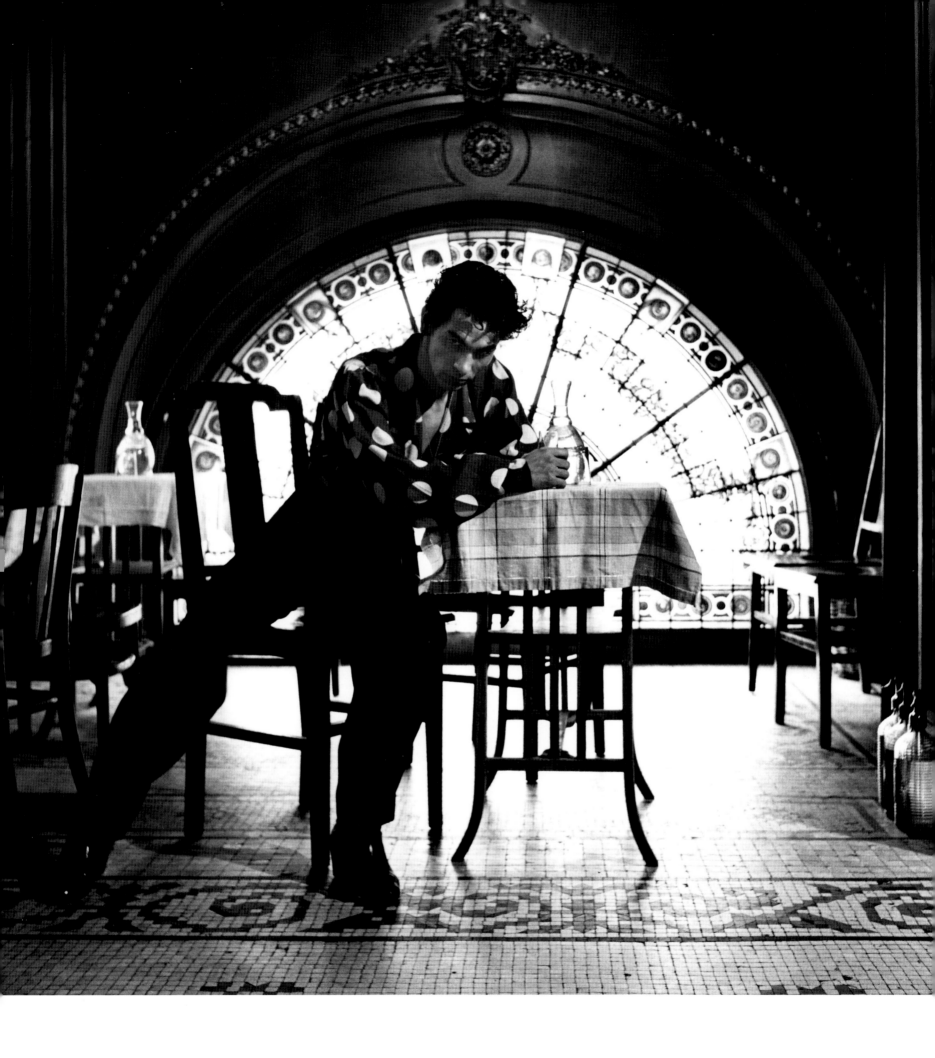

Manolo Vargas, Madrid, 1950

109

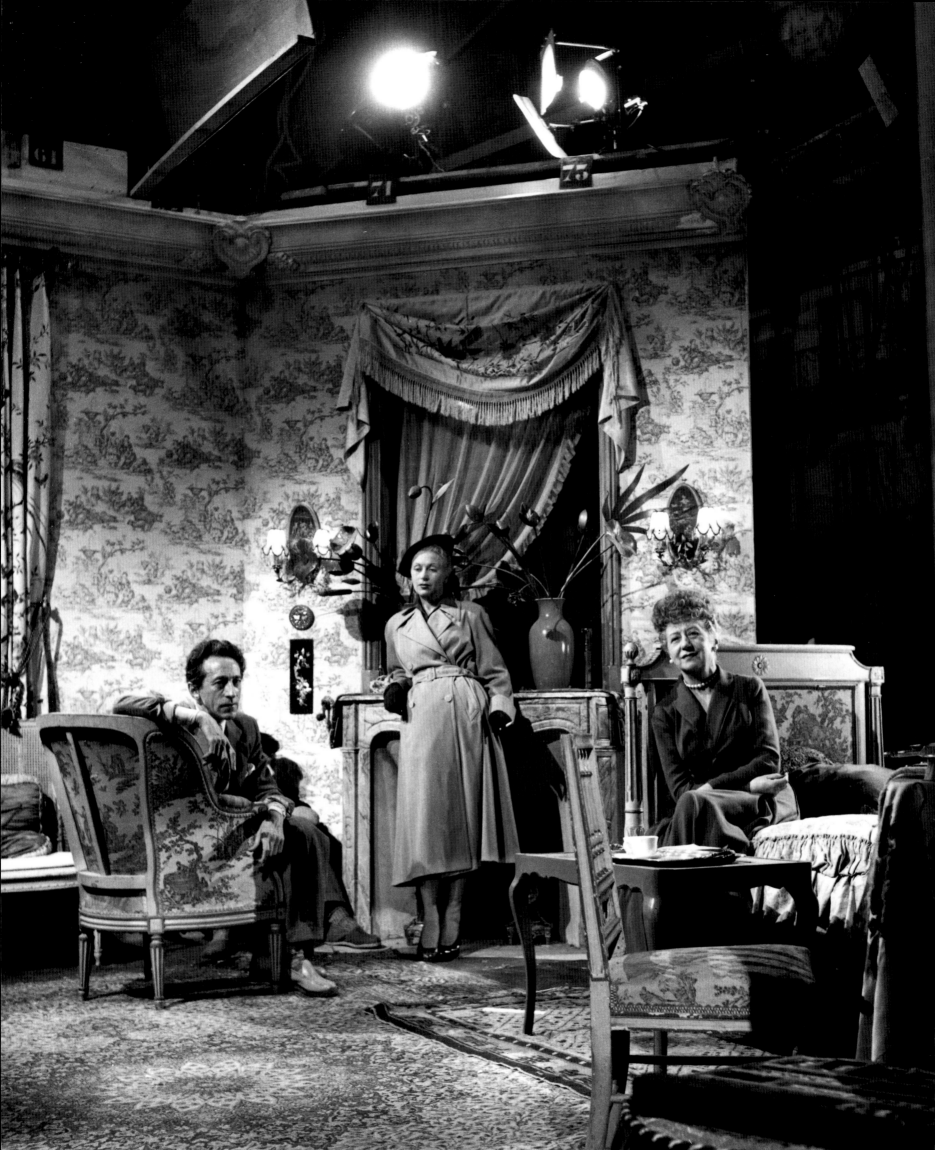

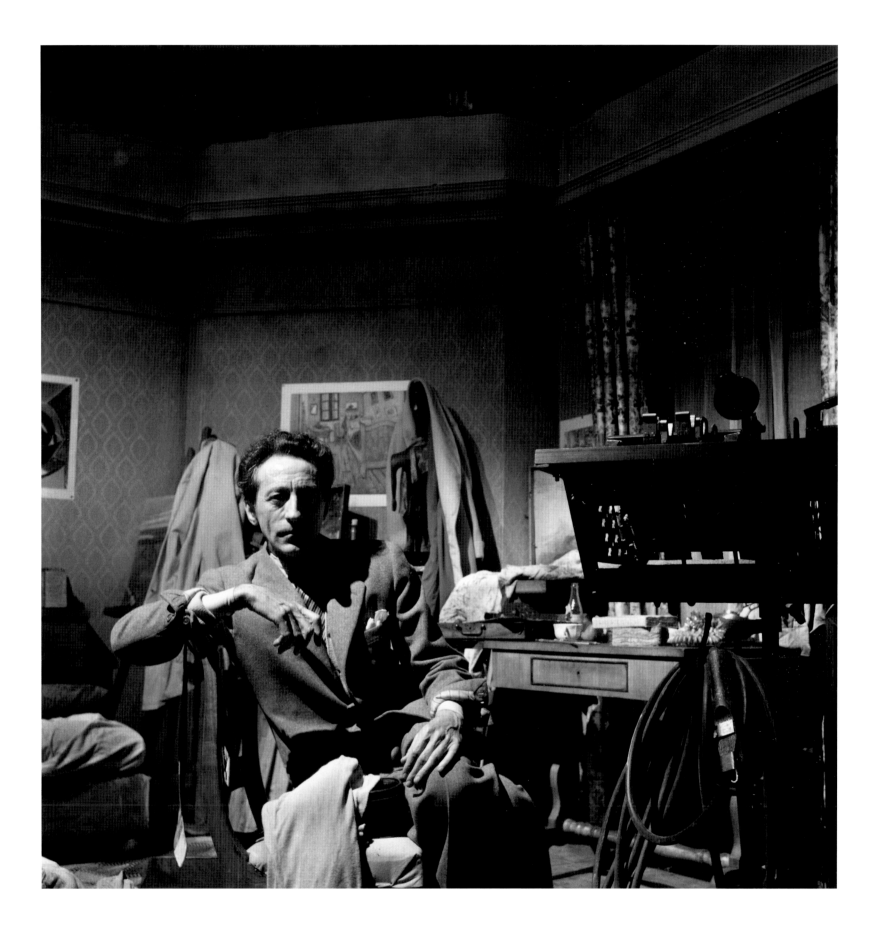

Jean Cocteau, Paris, 1948

Jean Cocteau, Josette Day, and Gabrielle Dorziat on the set of *Les Parents terribles*, 1948

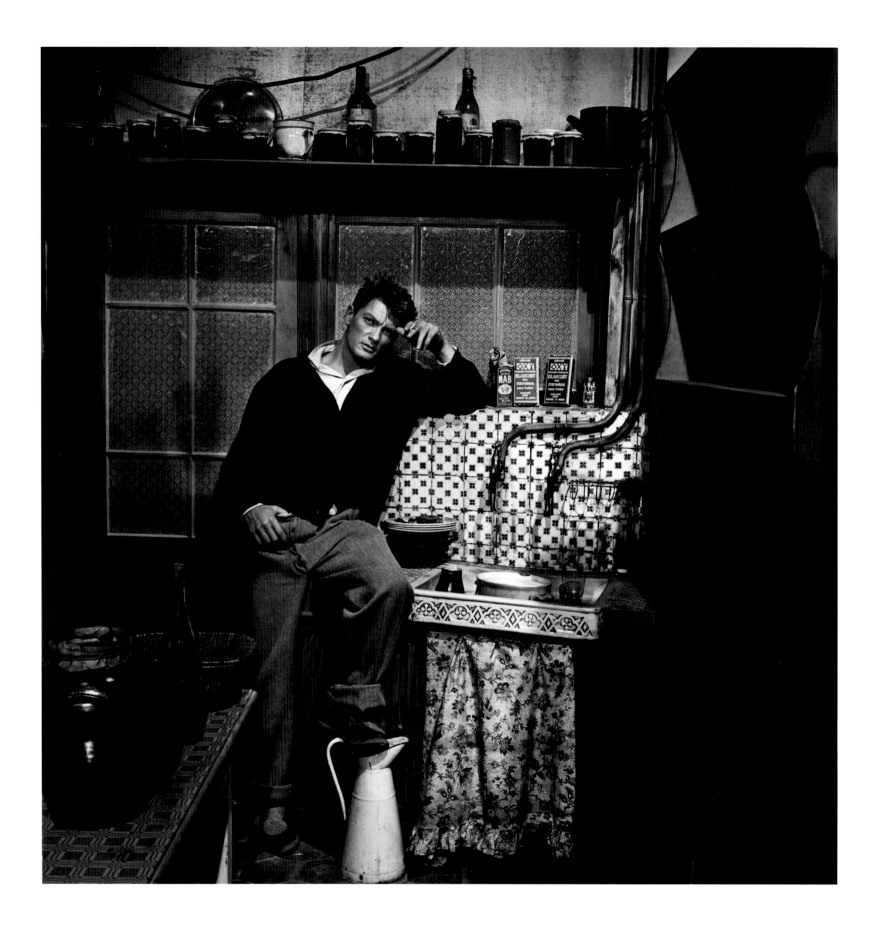

Jean Marais on the set of *Les Parents terribles*, Paris, 1948

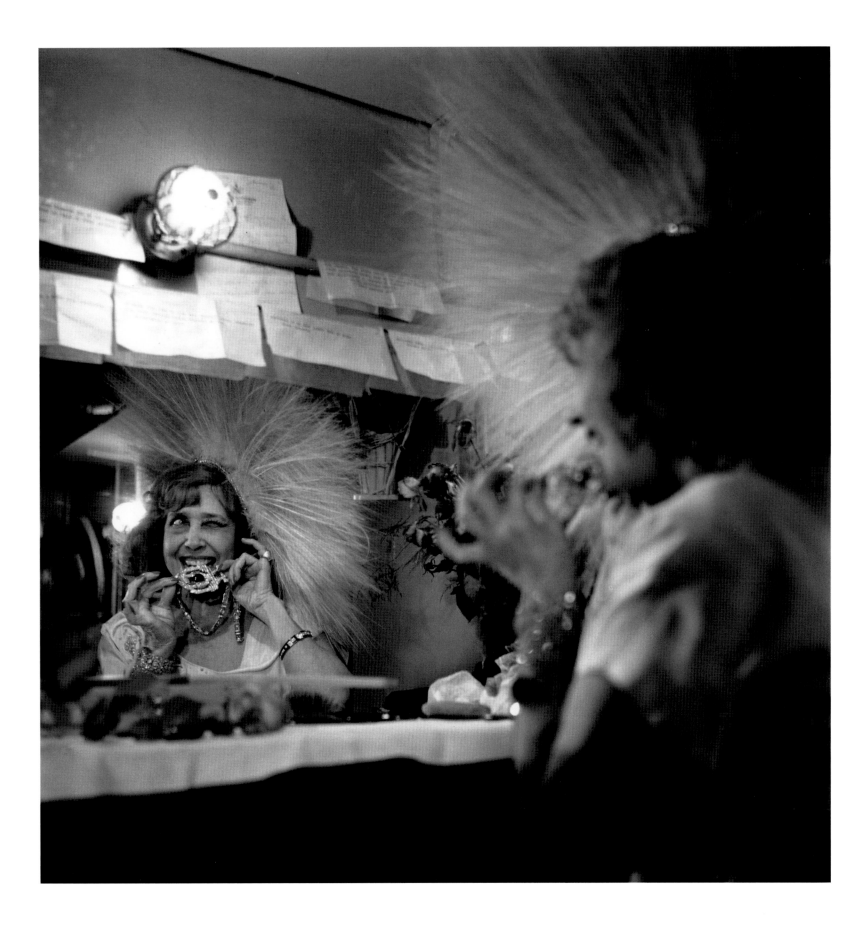

Mistinguett in her dressing room at the Club Tropicana, New York, 1951

Colette, Paris, 1948

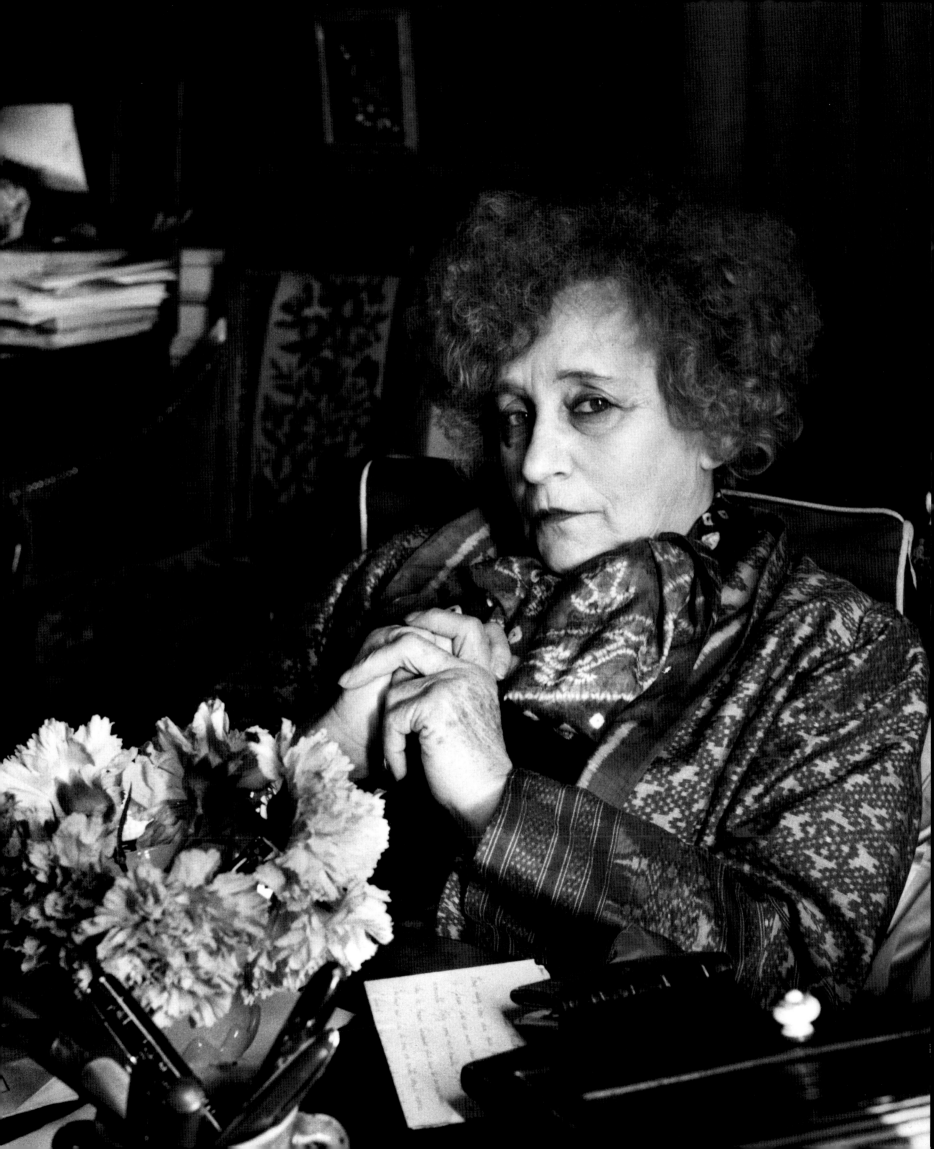

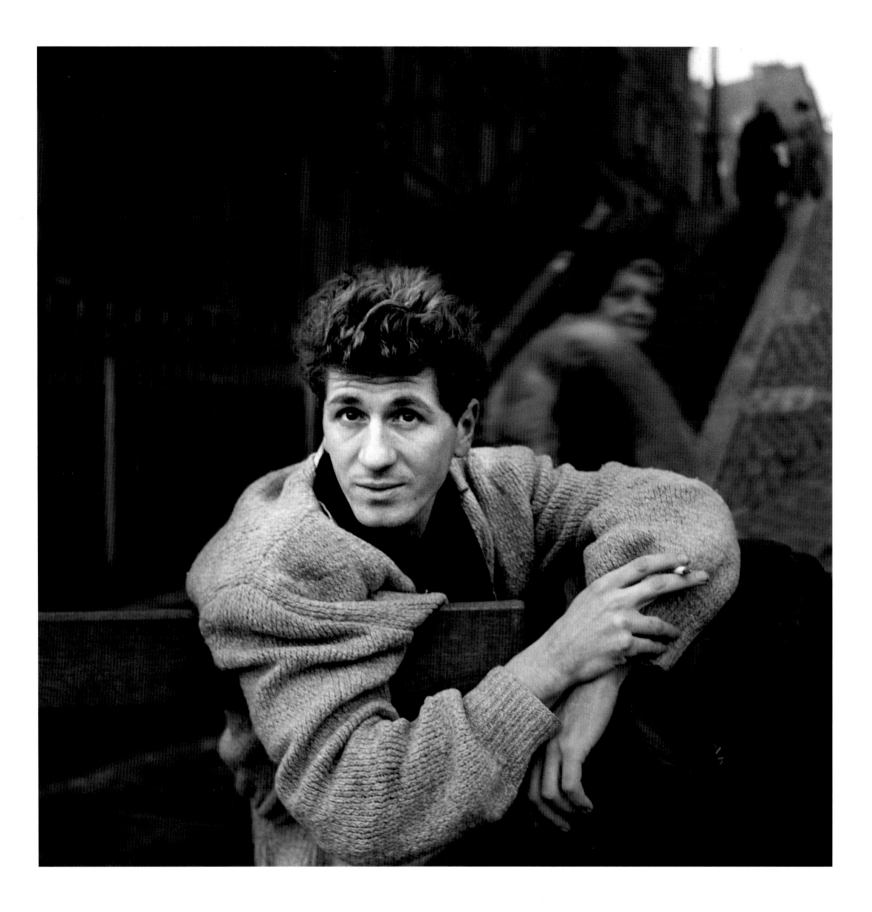

Mouloudji, Paris, 1948

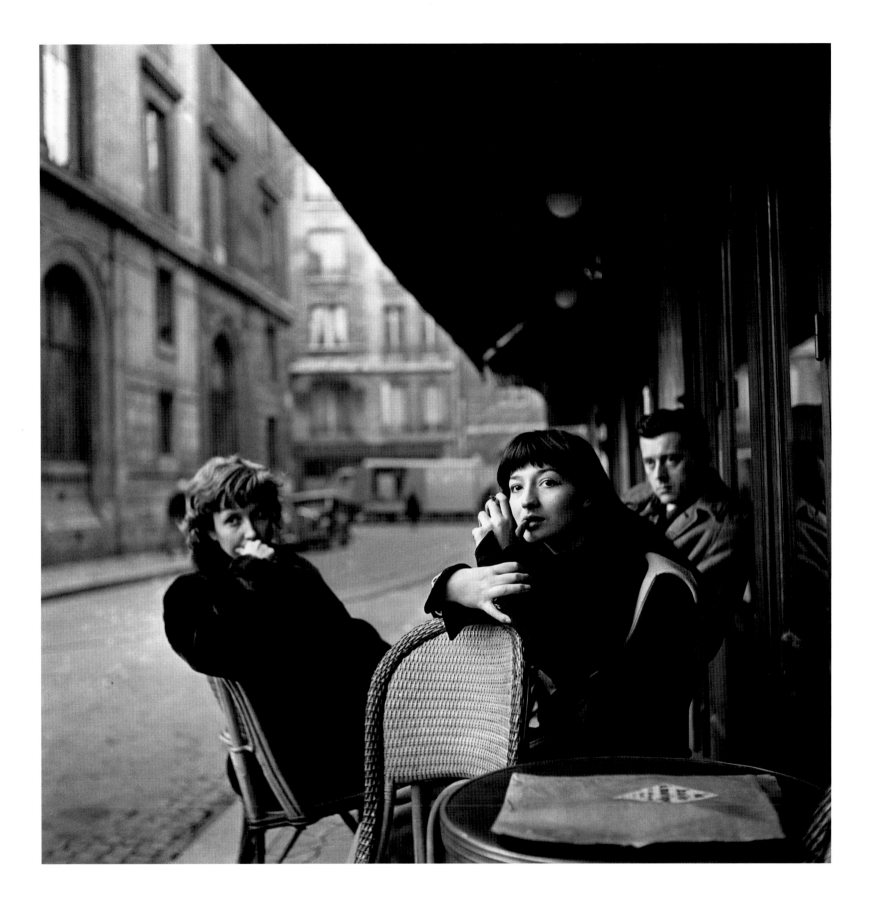

Juliette Gréco, Paris, 1948

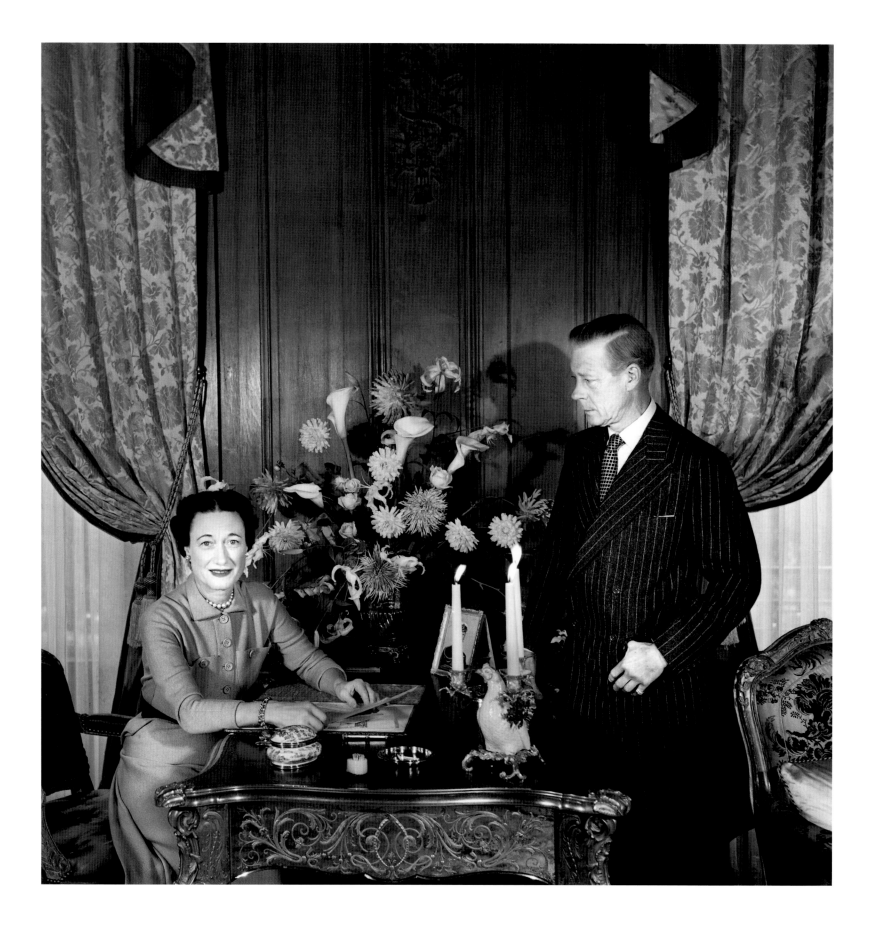

The Duke and Duchess of Windsor, Paris, 1950

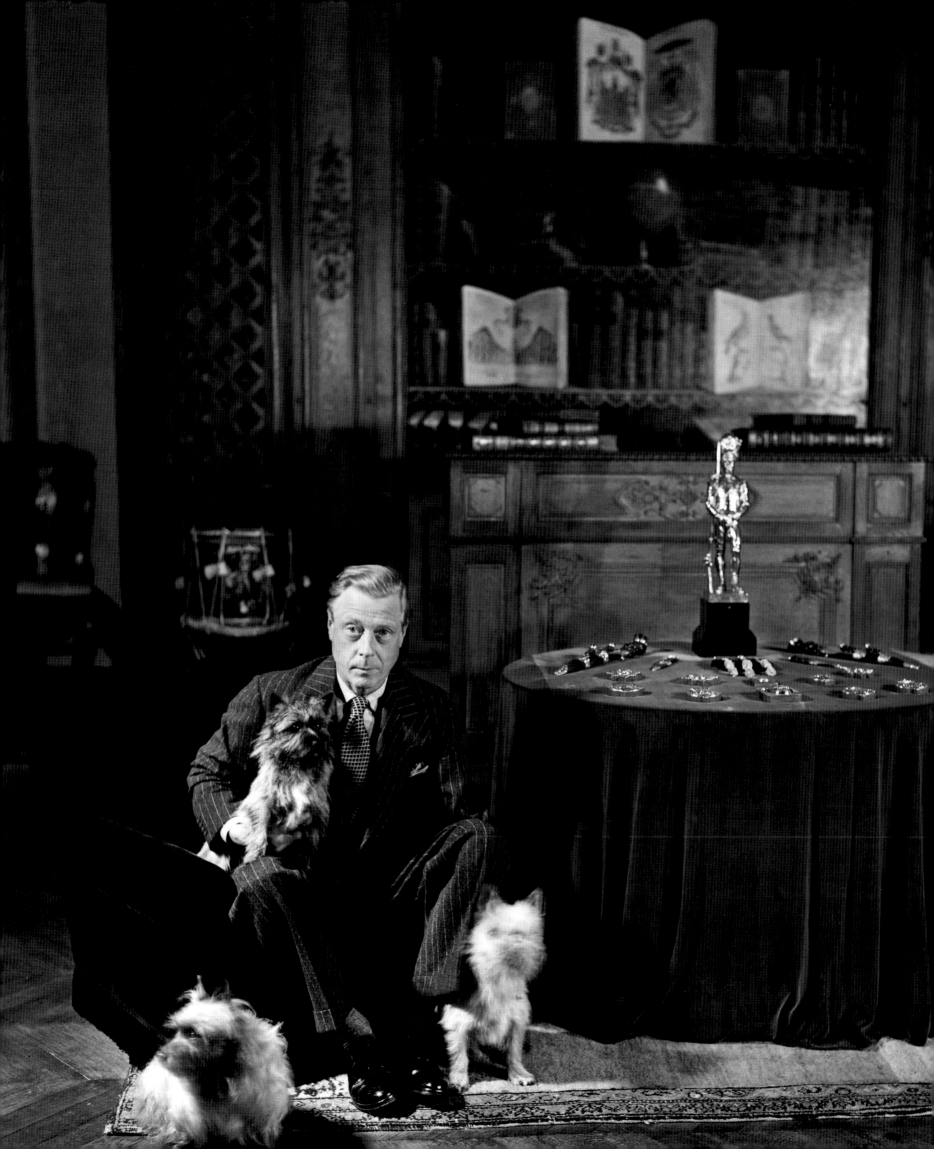

Bernard Berenson at I Tatti, his home outside Florence, c. 1948

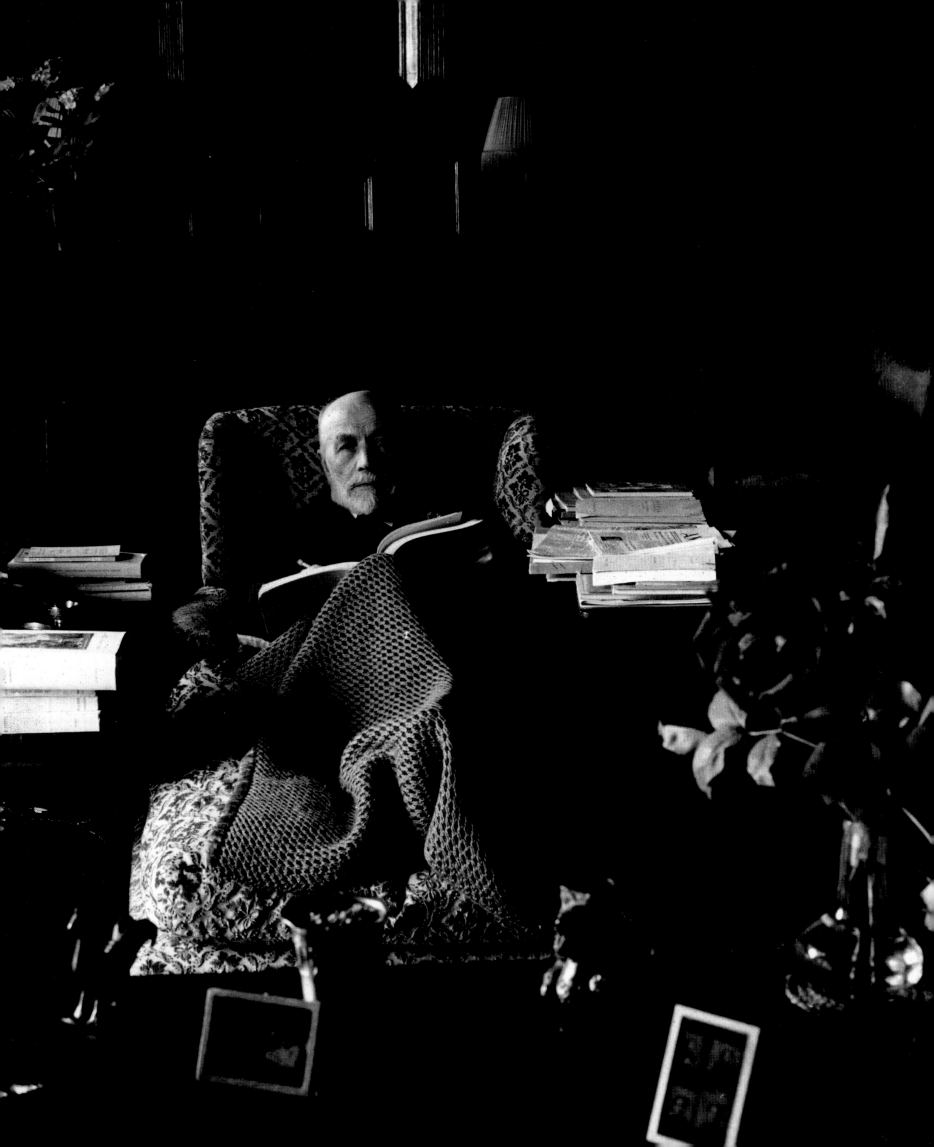

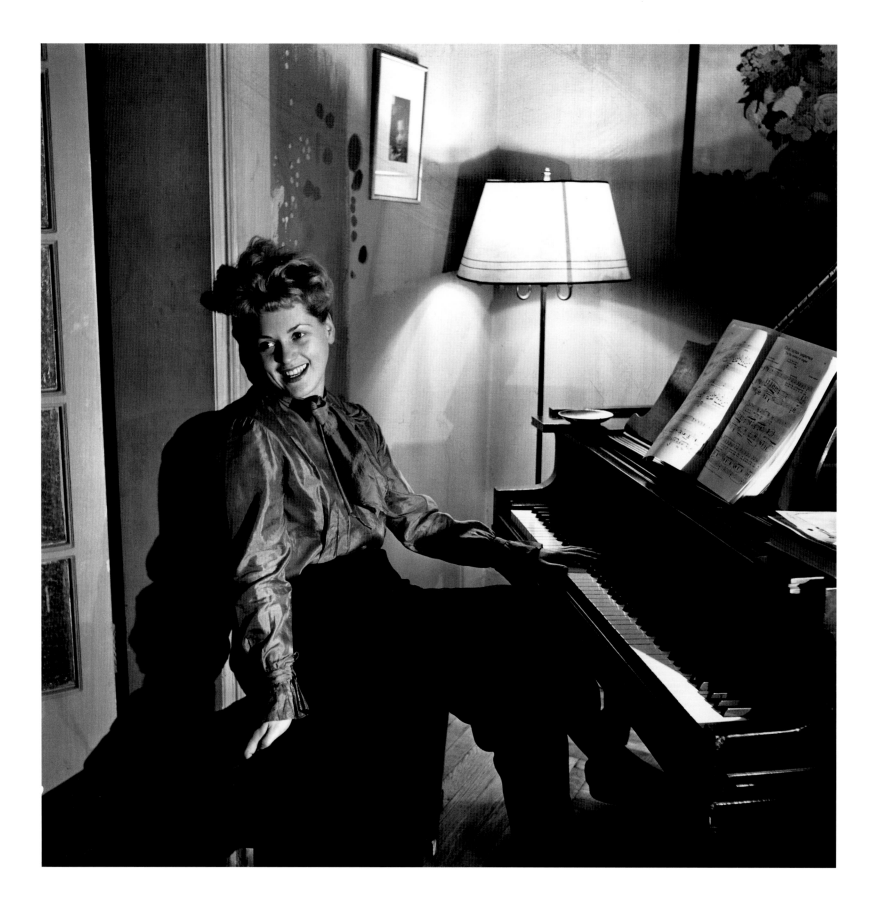

Judy Holliday during her run on Broadway in *Born Yesterday*, c. 1947

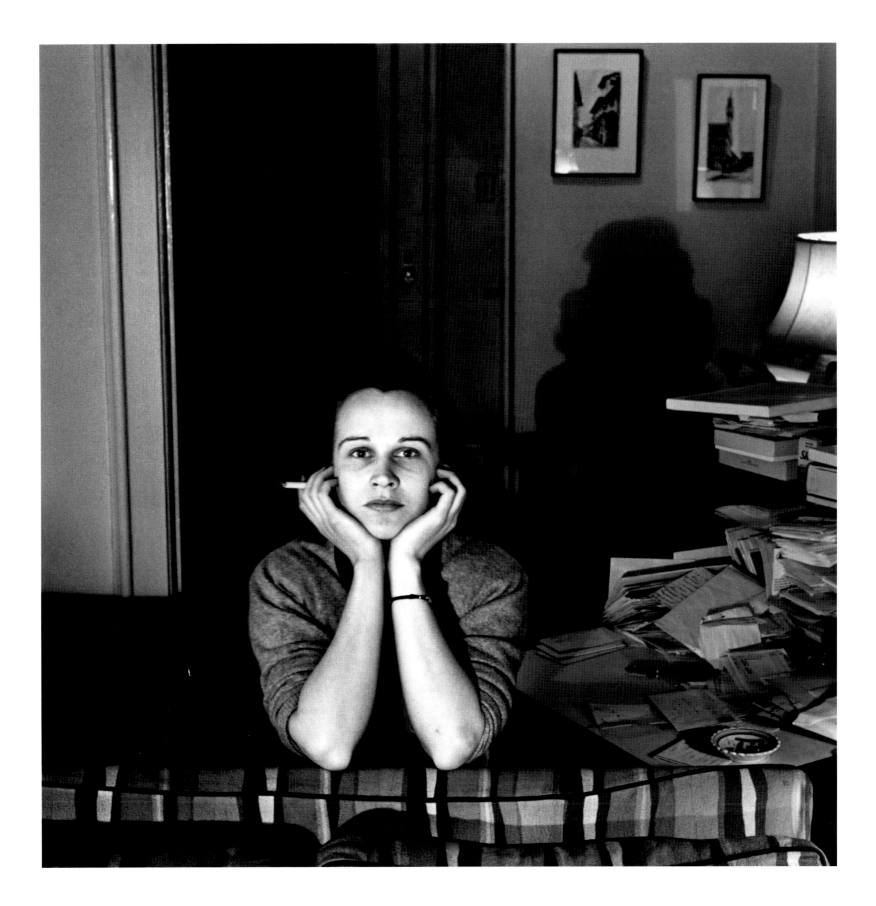

Kim Hunter at the time she was appearing on Broadway in *A Streetcar Named Desire*, 1948

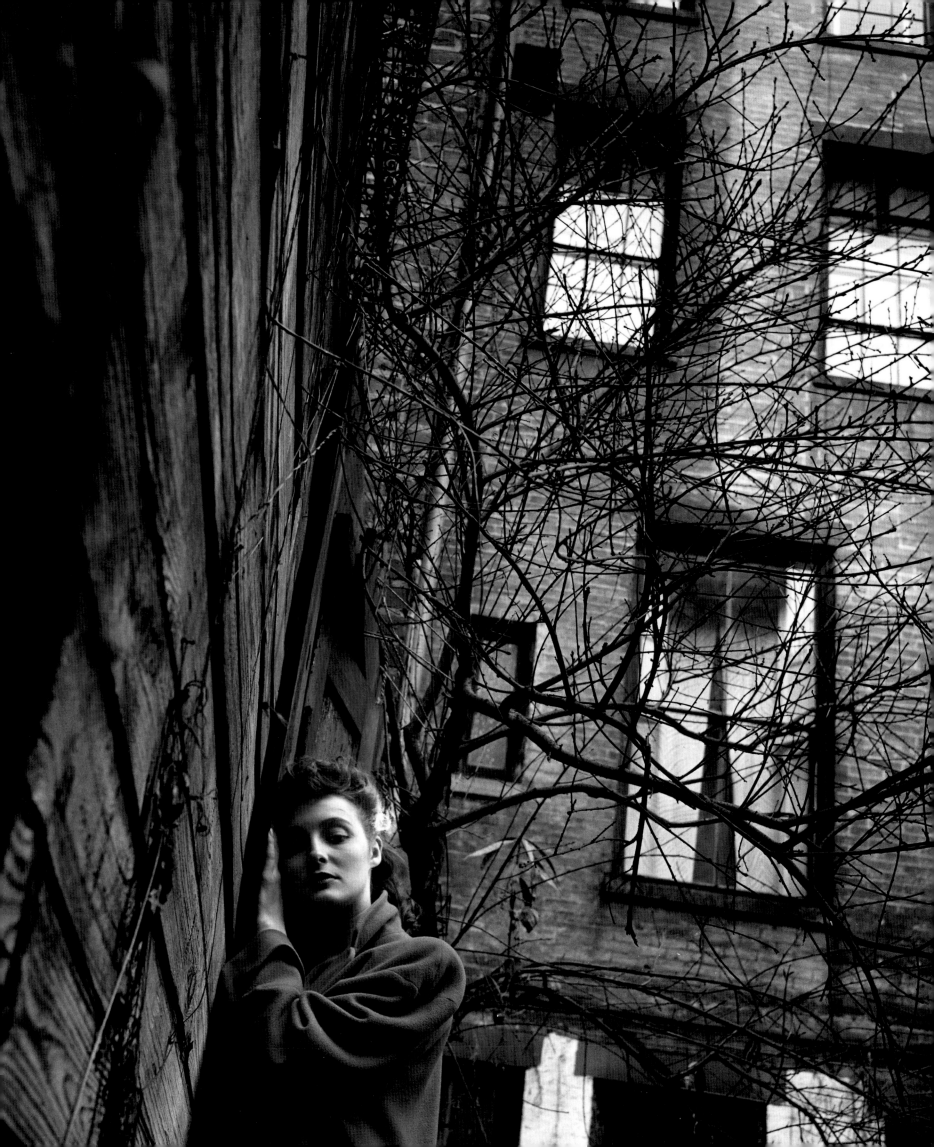

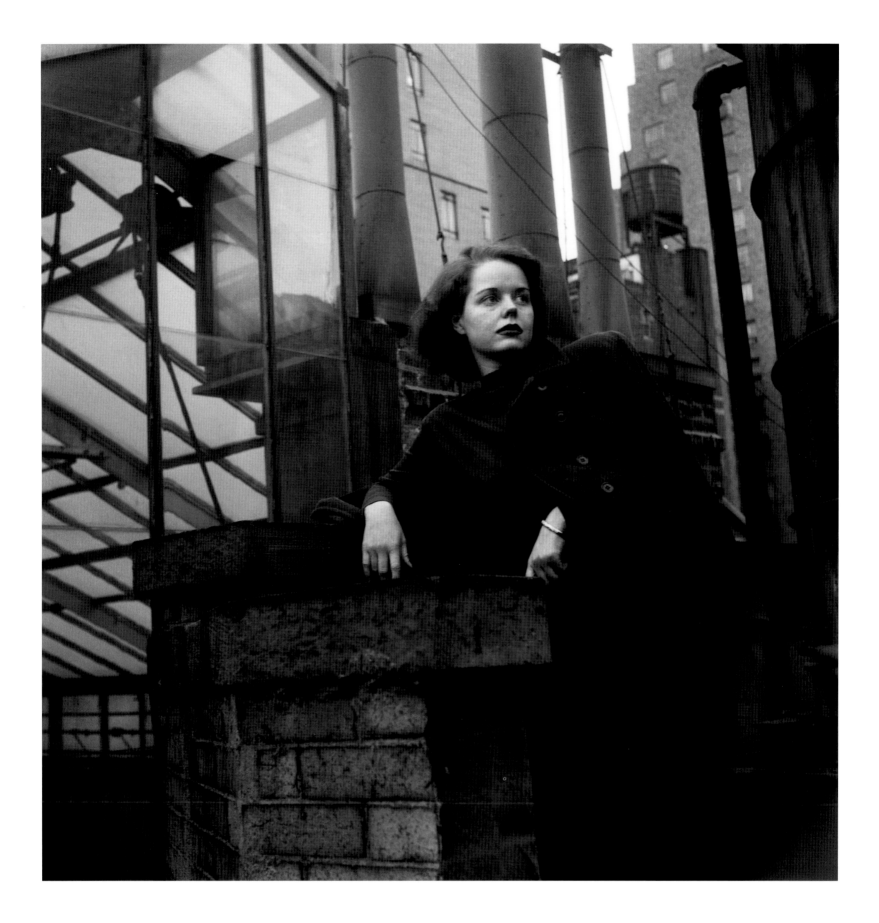

Beatrice Pearson at the time she was appearing on Broadway in *The Voice of the Turtle*, 1947

Patricia Neal at the time she was appearing on Broadway in *Another Part of the Forest*, 1947

Marlon Brando at the time he was appearing on Broadway in *A Streetcar Named Desire*, 1948

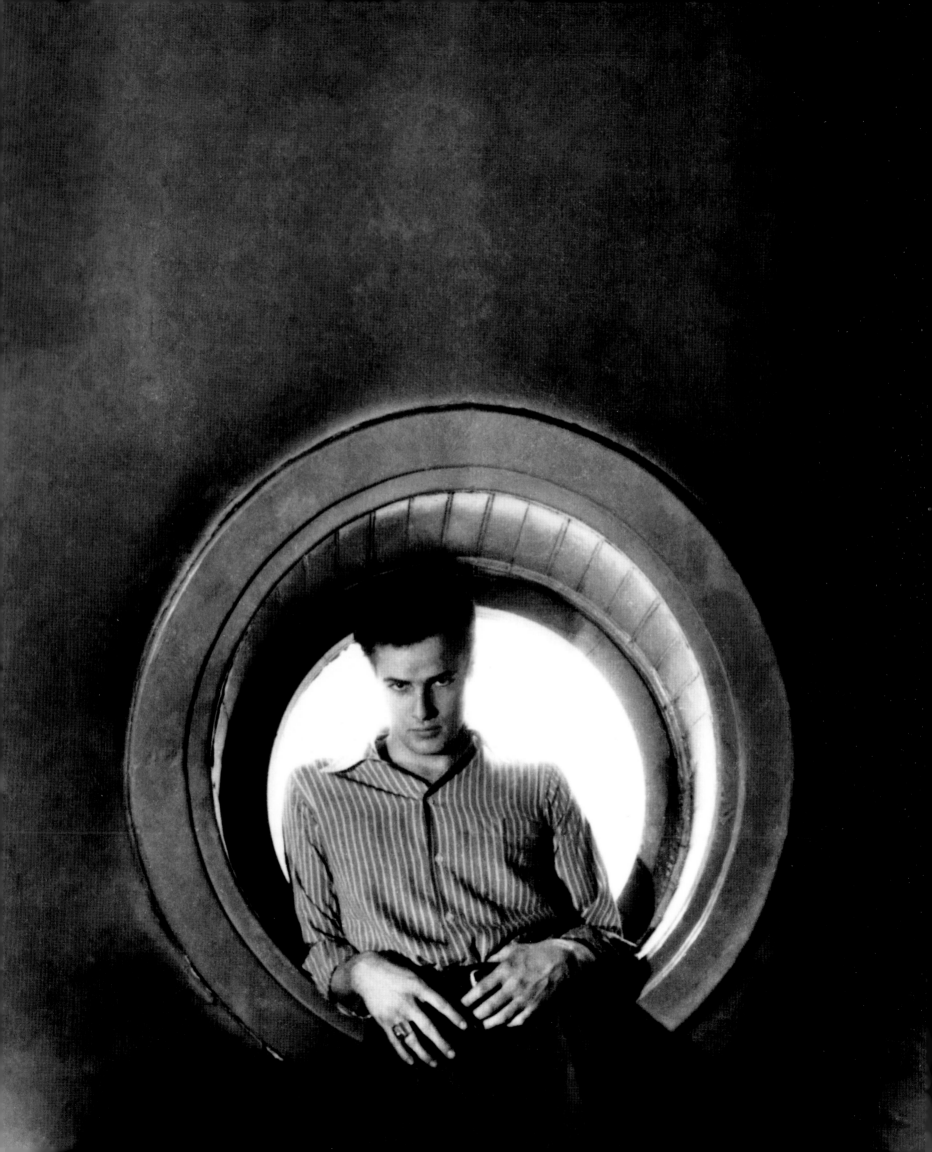

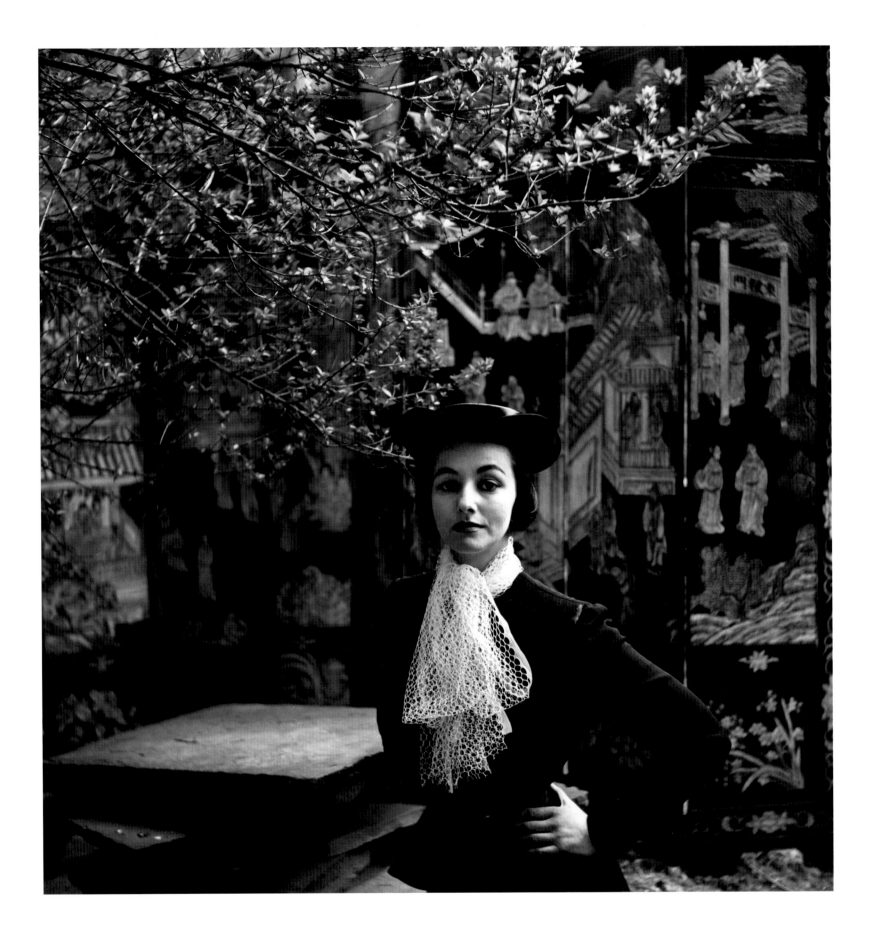

Sheri Martinelli, early 1950s

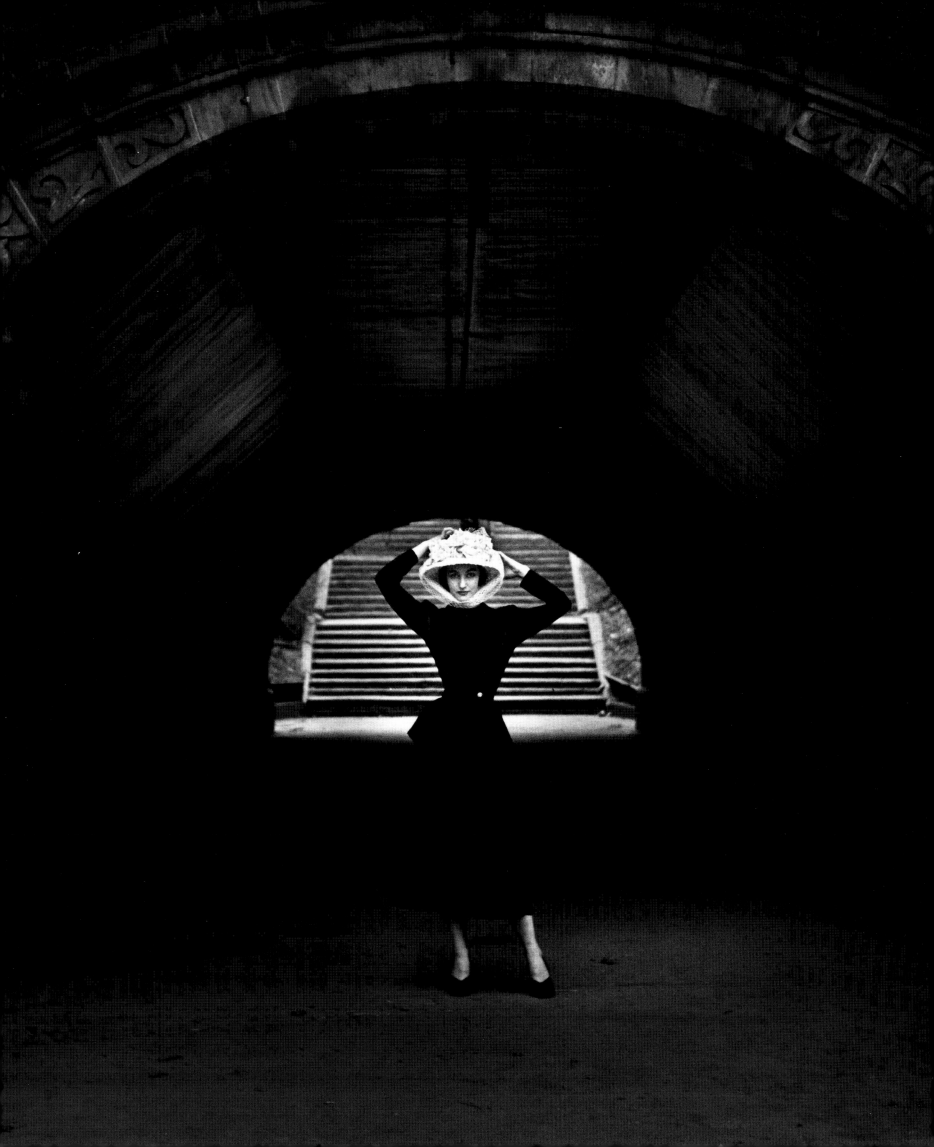

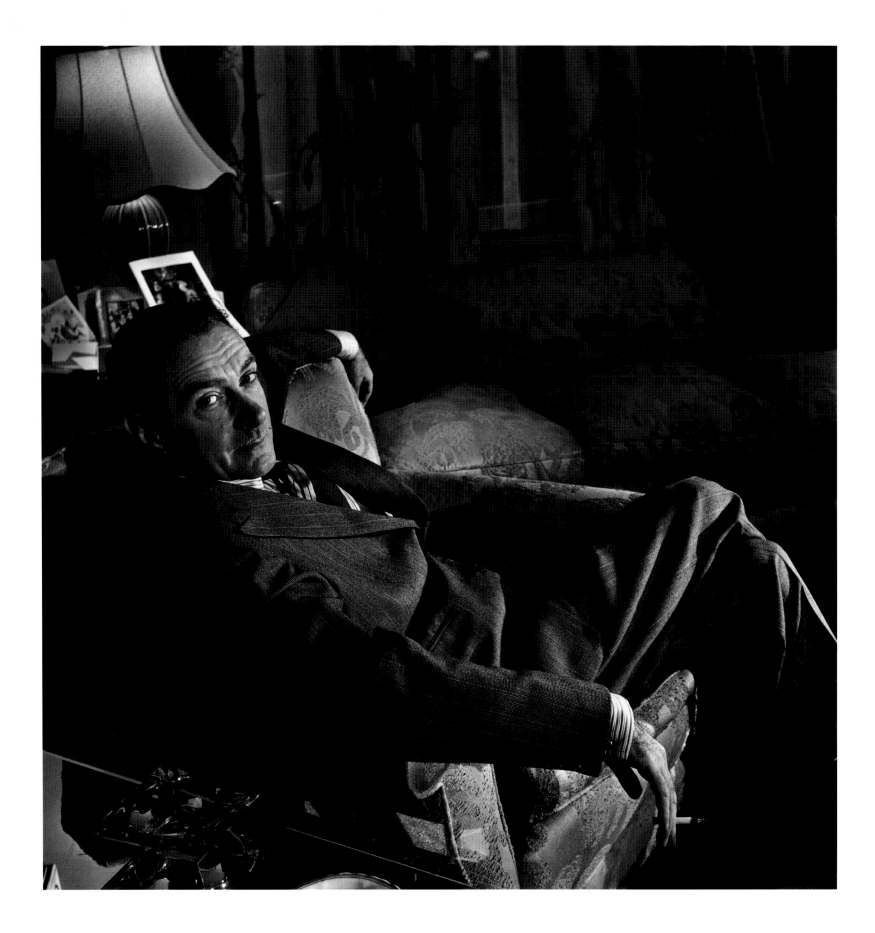

Clifton Webb, 1947

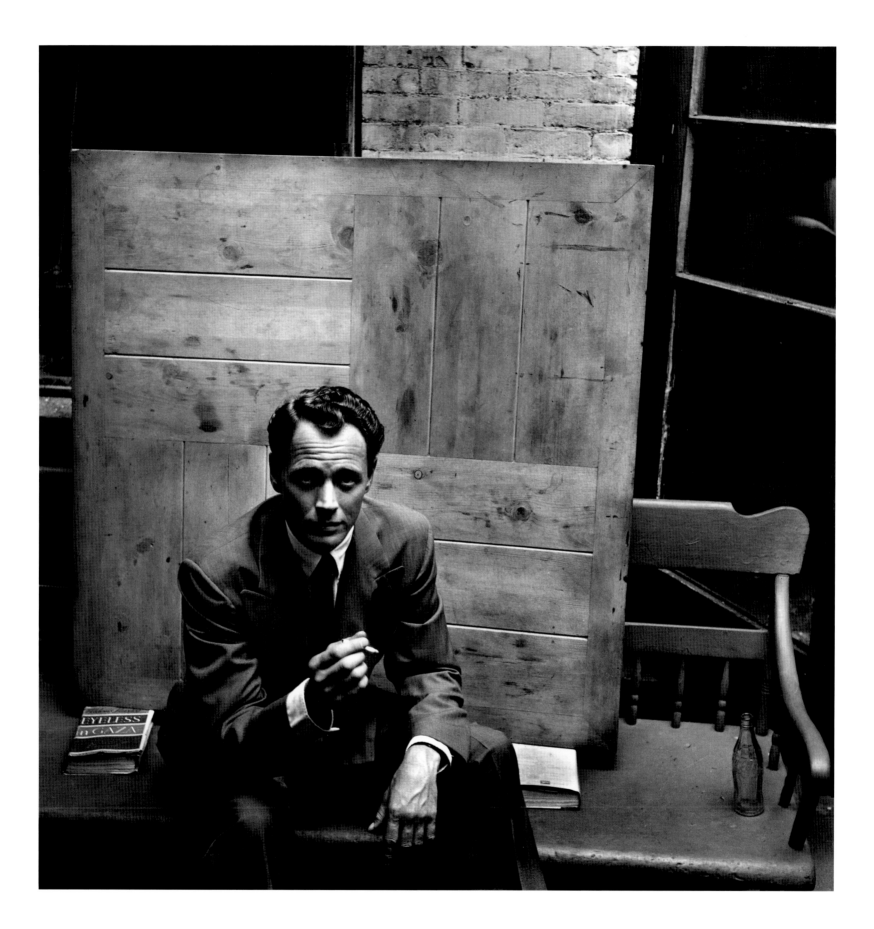

William Prince, early 1950s

John Dall, c. 1950

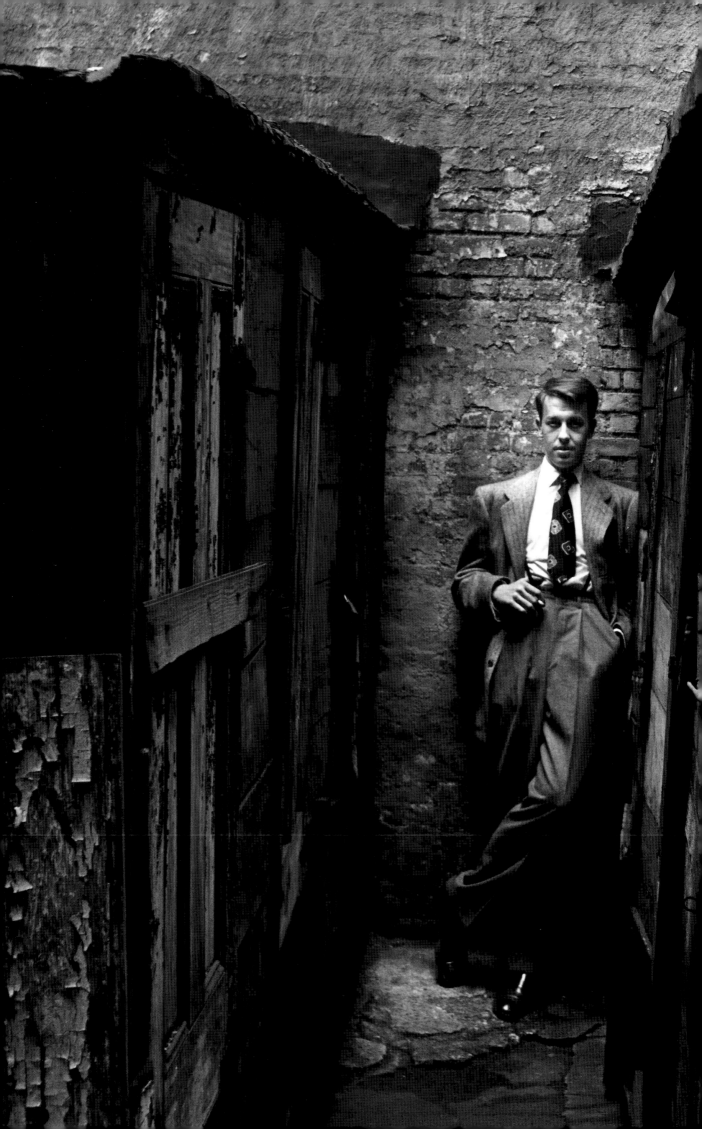

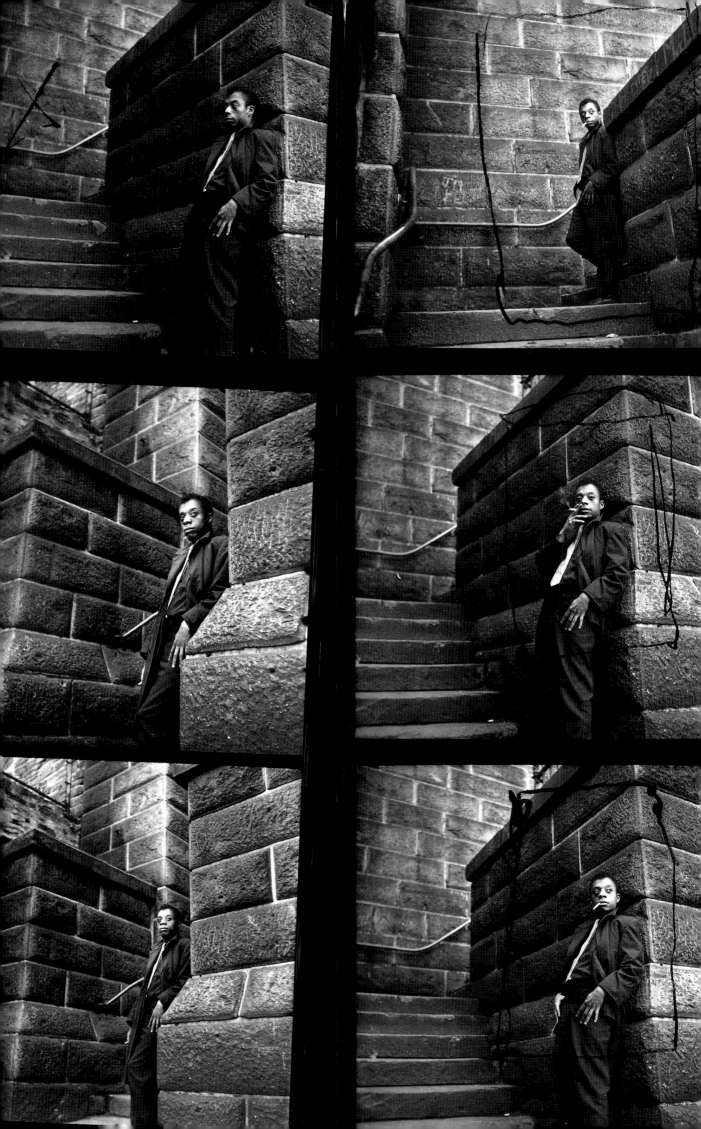

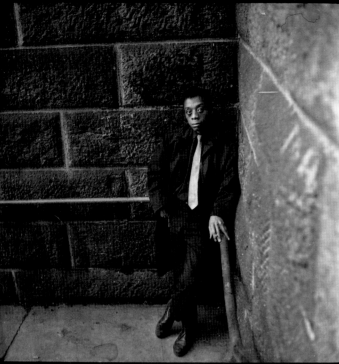
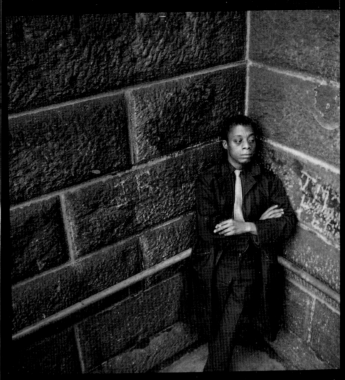

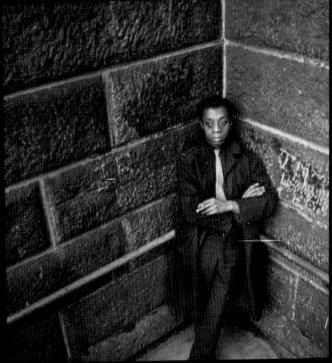
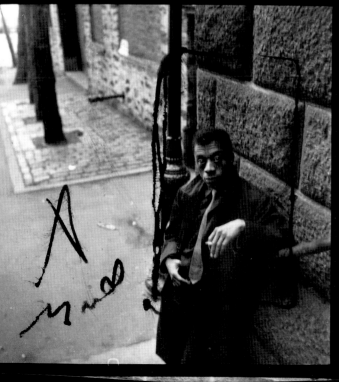
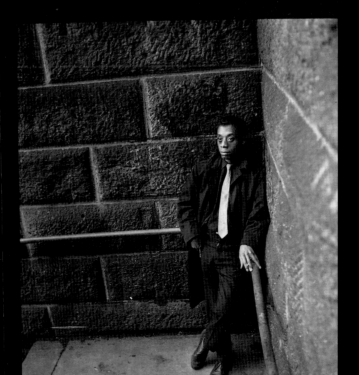

Cris Alexander, p. 101
American performer and designer
b. circa 1920
Alexander worked as a designer on Broadway and performed in the original Broadway productions of *On the Town* (1944), *Present Laughter* (1946), *Wonderful Town* (1953), and *Auntie Mame* (1956).

Shana Alexander, p. 44
American journalist
b. 1925
Alexander worked on the staff of *Harper's Bazaar* and *Flair* before she was hired as the first female staff writer and columnist for *Life* magazine in 1951. Later, she became the first female editor of *McCall's*. She was also a featured commentator on CBS's *60 Minutes*. She is the author of a number of books on celebrated American crimes and court cases.

Doe Avedon, p. 25
American actress
b. 1928
Doe Avedon worked sporadically as an actress in movies and television. She was married to photographer Richard Avedon in the 1940s.

Richard Avedon, p. 26
American photographer
b. 1923
After the war, Avedon attended the Design Laboratory taught by the *Harper's Bazaar* art director Alexey Brodovitch. Avedon worked on the staff of *Harper's Bazaar* from 1945 to 1965, when he moved to *Vogue* magazine. His first exhibition was at the Smithsonian Institute in 1962; since then he has exhibited worldwidein museums and galleries, including the Museum of Modern Art (1974), the Metropolitan Museum of Art (1978, 2002), and the Whitney Museum of American Art (1994–1995).

James Baldwin, p. 28, 29, 134, 135
American writer
1924–1987
Baldwin gained immediate recognition with his semiautobiographical first novel, *Go Tell It on the Mountain* (1953). Other books include *Giovanni's Room* (1956), *Another Country* (1962), and *The Fire Next Time* (1963).

Tallulah Bankhead, p. 44, 45
American actress
1903–1968
Bankhead's best-known role on Broadway was as Regina in the original production of Lillian Hellman's *The Little Foxes* (1939). Alfred Hitchcock cast her in her most memorable film role as one of the castaways in *Lifeboat* (1944).

Lillian Bassman, p. 27
American art director and photographer
b. 1917
Bassman apprenticed with the art director of *Harper's Bazaar*, Alexey Brodovitch, and eventually joined the staff of the magazine, where she helped Brodovitch launch the young women's career version of *Harper's Bazaar, Junior Bazaar*. She began her career as a photographer while working for the magazine.

Robert Russell Bennett, p. 58
American lyricist, composer, arranger, and orchestrator
1894–1981
Bennett scored over 300 productions for Kern, Gershwin, Berlin, Rodgers, and Lowe. The musicals include *Show Boat, Oklahoma, Annie Get Your Gun, South Pacific, The King and I, My Fair Lady, The Sound of Music*, and *Camelot*.

Bernard Berenson, p. 121
American art critic, connoisseur, and collector
1865–1959
Berenson was the foremost scholar of Italian Art of his generation; he devoted his life to the study and authentication of medieval and Renaissance works. His home in Italy, Villa I Tatti, is now a center for Italian Renaissance studies.

Marc Blitzstein, p. 56
American composer
1905–1964
Blitzstein's political opera, *The Cradle Will Rock*, was produced in 1937. The piece, directed by Orson Welles, was written for the Federal Theatre Project of the Works Progress Administration. He collaborated with Leonard Bernstein on the American adaptation (1952) of the Kurt Weill / Bertold Brecht production, *Three Penny Opera*.

Jane Bowles, p. 31
American writer
1917–1973
Bowles's first published novel was *Two Serious Ladies* (1943). Her play *In the Summer House* was produced in 1954. She wrote short stories, a novella, and in 1966, her final novel, *Plain Pleasures*. In her early twenties she married the writer/composer Paul Bowles.

Paul Bowles, p. 30
American composer, novelist, travel writer, and translator
1910–1999
During the 1930s and 1940s he wrote music for over 30 plays, ballets, and films, and collaborated with Tennessee Williams on his plays *The Glass Menagerie* (1945) and *Sweet Bird of Youth* (1959). He published his best-known novel *The Sheltering Sky* in 1949. His prolific published

works include: *The Delicate Prey* (1950), *Let it Come Down* (1952), *Spider's House* (1955), *Up Above the World* (1966), and *Collected Stories* (1979). He collected and translated Moroccan folklore, and also researched and recorded Moroccan music.

Charles Boyer, p. 88
French actor
1897 or 1899–1978
In the 1920s Boyer acted on the French stage, in silent films, and talkies. He established his reputation in Hollywood in the 1930s as the suave, sophisticated lover playing with such leading ladies as Bette Davis in *All This and Heaven Too* (1940) and Olivia de Havilland in *Hold Back the Dawn* (1941).

Marlon Brando, p. 12, 13, 127
American actor
b. 1924
Brando studied at the Dramatic Workshop and then at Lee Strasburg's Actors Studio where he was coached by Stella Adler. After appearing in four Broadway plays, he landed the role of Stanley Kowalski in Tennessee William's play, *A Street-car Named Desire* (1947), directed by Elia Kazan; his raw realistic performance brought him immediate fame and changed the style of acting in theatre and film worldwide.

Maeve Brennan, p. 38
American writer, born in Ireland
1917–1993
Brennan worked as a copywriter at *Harper's Bazaar* before joining *The New Yorker* staff (1949). From 1953 to 1981 she was a regular contributor to the "Talk of the Town" column under the pen name "The Long-Winded Lady." She died after spending a decade in and out of mental hospitals.

Pamela Brown, p. 46
British actress
1917–1975
Brown studied at the Royal Academy of Dramatic Art and although mainly a stage actress, she appeared in several films, including *One of our Aircrafts is Missing* (1942), *The Tales of Hoffman* (1951), *Richard III* (1955), *Lust for Life* (1956), *Cleopatra* (1963), *Becket* (1964), *A Funny Thing Happened on the Way to the Forum* (1966), and *Wuthering Heights* (1970).

Joe Bushkin, p. 44, 45
American musician
b. 1916
Bushkin began playing trumpet and piano professionally while still in his teens. By the 1930s, he was recording with Eddie Condon, Muggsy

Spanier, and Billie Holiday. In 1940 he began playing with Tommy Dorsey. After war service, Bushkin worked with Benny Goodman and Louis Armstrong. He continued to record and perform with a variety of artists until the mid-1980s.

Truman Capote, p. 6, 7, 20, 21, 22, 23
American writer
1924–1984
The southern writer and self-proclaimed genius said, "there was nobody like me before, and there ain't ever gonna be anyone like me after I'm gone." His books include *Other Voices, Other Rooms* (1948), *Breakfast at Tiffany's* (1958), and *In Cold Blood* (1966).

Hoagy Carmichael, p. 49
American songwriter
1899–1981
Carmichael became celebrated in the 1920s for his tunes "Riverboat Shuffle," and his most popular song, "Stardust." He appeared in ten films, mostly playing himself, including *To Have and Have Not* (1944) and *The Best Years of Our Lives* (1946).

Mindy Carson, p. 34
American pop vocalist
b. 1927
Carson first hit the charts in 1946 singing a duet with Harry Cool called "Rumors are Flying." She continued to have chart success in the 1950s.

Camilo José Cela, p. 84
Spanish writer
1916–2002
He is best known for his first novels *La Familia De Pascual Duarte* (1942) and *La Colema*, or *The Hive* (1951). Both books were banned in Spain when initially published. Cela developed a dark, violent, realistic writing style which is now called Tremendismo. He received the Nobel Prize for Literature in 1989.

Gower Champion, p. 32
American dancer, choreographer, actor, and director
1919–1980
After the war, he formed a dancing partnership called Gower and Bell, with Marge Belcher, a high-school friend. They married in 1947 and as Marge and Gower Champion they starred together in film musicals of the 1950s. He also directed and choreographed the Broadway hits *Bye, Bye Birdie* (1960), *Carnival* (1961) and *Hello Dolly* (1964).

Marge Champion, p. 32
American dancer, actor, and choreographer
b. 1921
She began dancing as child and became the cartoonist's movement model for two Walt

Disney films: the heroine in *Snow White and the Seven Dwarfs* (1937) and the Blue Fairy in *Pinocchio* (1940).

Stewart Chaney, p. 48
American producer, director, and designer
1907–1969
Chaney produced, directed, and/or designed lighting, sets, and costumes on dozens of Broadway plays from 1934–1964.

Carol Channing, p. 59
American comic actress and entertainer
b. 1921
Channing won success on Broadway with the role of Lorelei Lee in the comedy *Gentlemen Prefer Blondes* (1949). She created the role of the matchmaker Dolly Levi in the Broadway production of *Hello Dolly* (1964) and has revived the role for over 5,000 performances in productions spanning 30 years.

Sarah Millicent Hermione Churchill, p. 71
British actress
1914–1982
The film and television actress was the daughter of Winston Churchill. Her most memorable film appearance was in the musical *The Royal Wedding* (1951). Her television series, *The Sarah Churchill Show*, aired for only one year in 1951.

Montgomery Clift, p. 2, 36, 37
American actor
1920–1966
Clift was one of the founding members of the Actor's Studio in 1947. He appeared on Broadway at age 13 and achieved star status on Broadway at age 17 in the play *Dame Nature*. After continually turning down Hollywood scripts and offers, he made his film debut in the western *Red River* (1948).

Jean Cocteau, p. 110, 111
French poet, novelist, playwright, director, and artist
1889–1963
According to Cocteau, "when a work appears to be ahead of its time, it is only the time that is behind the work." He was a leader of the Parisian avant-garde and is best remembered for his poetry and films.

Colette (Sidonie-Gabrielle Colette), p. 115
French writer
1873–1954
The French writer wrote on themes of the joys and sorrows of love and is credited with being the first writer to introduce the strong, sexual, female heroine to the novel. She claimed herself to be a mental "hermaphrodite." She was the first woman in France to receive a state funeral.

Gary Cooper, p. 69
American actor
1901–1961
Cooper's explanation for his success was, "People ask me how come you been around so long? Well, it's through playing the part of Mr. Average Joe American." His films include *Meet John Doe* (1941), *Sergeant York* (1941), *For Whom the Bell Tolls* (1943), and *High Noon* (1952).

James Gould Cozzens, p. 82
American writer
1903–1978
Cozzens's novels explore the moral struggles of the upper-middle-class man. He won the Pulitzer Prize in 1948 for his novel *Guard of Honor*.

John Dall, p. 133
American actor
1918–1971
Dall appeared on Broadway before acting in films. He went to Hollywood and gained immediate recognition with his Oscar-nominated performance opposite Bette Davis in *The Corn is Green* (1946). After that early success, his inconsistent film career included a leading role in Alfred Hitchcock's *Rope* (1948).

George Davis, p. 33
American writer and editor
1906–1957
Davis published a bestselling novel, *Opening of the Door*, in 1931. He worked as the fiction editor of *Harper's Bazaar* and later at *Mademoiselle*, where he published the works of Truman Capote and Carson McCullers for the first time. He also worked as the features editor of *Flair* magazine. At the time of his death, he was assisting his wife, Lotte Lenya, in reviving the works of her first husband, Kurt Weill.

Alfred de Liagre, Jr., p. 48
American theatre operator/owner, producer, and director
1904–1987
Along with producing his own shows, he worked as the executive producer and managing director of The American National Theatre Academy (ANTA); the organization was chartered in 1935 by the U.S. Congress to create a National Theatre Conservatory.

Agnes de Mille, p. 107
American choreographer
1905–1993
Her choreography was groundbreaking and was credited with being uniquely American in its fusion of folk, ballet, and modern dance. Her film and Broadway choreography is also considered revolutionary in that it integrated song, dance, and action. The most relevant examples are *Oklahoma* (1943) and *Carousel* (1945).

Luli Deste (Luli von Hohenberg), p. 103
Austrian actress
1901–1951
Deste first appeared in European films and then went to Hollywood in 1937, where producers were hoping she would be another star with the international cachet of Dietrich or Garbo; however, she only had a brief career in American films through the early 1940s.

Isak Dinesen (Baroness Karen Blixen), p. 78
Danish writer
1885–1962
She wrote about her experiences on a coffee plantation in Kenya in her autobiography *Out of Africa* (1937). Her other works include *Seven Gothic Tales* (1934), *Winter's Tales* (1943), *Last Tales* (1957), and *Anecdotes of Destiny* (1958).

José Ferrer, p. 85
American actor, producer, and director; born in Puerto Rico
1909–1992
Ferrer is best remembered for his unforgettable performance in the title role of *Cyrano de Bergerac* (1950), for which he won an Academy Award for best actor.

Janet Flanner, p. 41
American journalist
1892–1978
In 1925, *The New Yorker* published Flanner's first "Letter from Paris." It was a professional relationship that would last from 1925 until 1976; Flanner would publish her observations on Parisian and European culture, art, social life, and politics biweekly in the magazine under the pen name Genêt.

Fontana Sisters (Sorelle Fontana), p. 53
Italian fashion designers
Zoe, 1911–1978
Micol, b.1913
Giovanna, b.1915
Zoe, Micol, and Giovanna Fontana learned dress designing from their mother, Amabile, who had inherited the family business. The sisters are best remembered for designing Ava Gardner's spectacular wardrobe in the 1954 film, *The Barefoot Contessa*.

John Ford, p. 68
American film director
1895–1973
Ironically, one of America's most famous directors had a serious eye problem, and he often appeared in public with an eye patch or dark glasses. Ford said, "Anybody can direct a picture once they know the fundamentals. Directing is not a mystery; it's not an art. The main thing about directing is: photograph the people's eyes."

Brendan Gill, p. 39
American writer and preservationist
1914–1997
Gill worked at *The New Yorker* magazine for over sixty years, where he contributed articles on film, drama, and architecture. He never retired.

Mathias Goeritz, p. 97
Prussian-born artist, architect, and educator
1915–1990
Goeritz said, "when people ask me to define my work, I used to say that I considered it an experiment of poetry in space. The truth is that it is a rather desperate attempt to find the right language for a prayer." Goeritz's attempt, whether through teaching, sculpting, writing, or building, was always to make a physical expression of something spiritual.

José Greco, p. 106
American dancer and choreographer, born in Italy
1918–2000
Born in Italy, raised in Spain, and moving to Brooklyn at the age of ten, he began his career in 1937. For over sixty years his name was synonymous with flamenco and Spanish dance, the dance styles he introduced to a worldwide audience.

Juliette Gréco, p. 117
French singer
b. 1927
In France, Gréco is the idol of a generation whose childhood, like hers, had been tarnished by the war. After the war, she performed in the cafés and jazz clubs of the Left Bank and gained fame as a smoky-voiced chanteuse. Her song, "Je Suis Comme Je Suis" became an anthem for the European youth of the late 1940s.

Chaim Gross, p. 93
American artist, born in Austria
1904–1991
Although Gross worked in many mediums, he is widely known for his joyous and fanciful wood sculptures. The recurring themes in his work are based on Jewish traditions, motherhood, and the circus.

Alec Guinness, p. 64
English actor
1914–2000
This gifted actor played an extraordinary range of roles and worked with many directors, but he had a lifelong collaboration with director David Lean, appearing in his films *The Bridge Over the River Kwai* (1957), for which he won the Academy Award for best actor, *Lawrence of Arabia* (1962), *Doctor Zhivago* (1965), and *Passage to India* (1984).

Juanita Hall, p. 60
American actress and singer
1901–1968
After being classically trained at Julliard, she made her debut on Broadway in *Sailor Beware* in 1935. Hall won a Tony for her role as Bloody Mary in *South Pacific* (1949). She revived the role for the movie in 1959, but her singing voice was overdubbed.

Rex Harrison, p. 63
English actor
1908–1990
He played the suave sophisticate on both stage and screen. He was the toast of London and New York playing the role of Professor Henry Higgins in *My Fair Lady* (which ran on Broadway from 1956–58). He received the Tony Award for his Broadway performance, and also an Academy Award for his role in the film version (1964).

Stanley William Hayter, p. 102
English artist
1901–1988
Hayter is considered the greatest British printmaker of this past century. In 1927, Hayter established the now-famous Atelier 17, where he collaborated with many artists, including Chagall, Ernst, Giacometti, Miró, and Picasso.

Katharine Hepburn, p. 42, 43
American actress
b. 1907
Hepburn introduced the modern, no-nonsense, self-reliant American woman to the big screen. Her contributions to film have been recognized with more Oscars and Oscar nominations than any other actor in the best acting category, with the exception of Meryl Streep.

Judy Holliday, p. 122
American actress
1922–1965
Her breakthrough came in the comedic role of Billie Dawn on Broadway in the play *Born Yesterday* (1946); she earned an Academy Award for her performance in the film version (1950). A victim of the "red scare," Holliday was blacklisted for ten years after being subpoenaed before the House Committee on Un-American Activities.

Kim Hunter, p. 123
American actress
1922–2002
She trained at the Actor's Studio and starred on Broadway with Marlon Brando in *A Streetcar Named Desire* (1947), playing Stella Kowalski. The role won her the Academy Award for best supporting actress in the film adaptation in 1951. She was blacklisted during the anticommunist scare of the 1950s, most likely because she was a vocal supporter of the 1949 World Peace Conference.

range he said, "I play John Wayne in every picture regardless of the character, and I've been doing all right, haven't I?"

Clifton Webb, p. 130
American actor
1891–1966
He appeared in silent films and on stage, and in his first sound film in 1944, when he played the villain in *Laura*. After receiving an Academy Award nomination for his performance, he was typecast as the acerbic, sophisticated, waspish bachelor.

Max Weber, p. 91
American artist, born Russia
1881–1961
Weber and his family settled in Brooklyn just after the turn of the century. He studied at Pratt Institute and then went to Europe and was one of the first artists to expose modernism to America. His works are Cubist- and Fauvist-inspired and his paintings often explore social themes and Jewish traditions.

Tennessee Williams, p. 15, 81
American playwright and screenwriter
1911–1983
Southern writer and "poet of the theatre," Tennessee Williams wrote two of the most influential plays of this past century: *The Glass Menagerie* (1946) and the Pulitzer Prize-winning

A Streetcar Named Desire (1947). "I have always depended on the kindness of strangers," spoken by the character Blanche Dubois, is one of most-often repeated lines in American theatre.

Donald Windham, p. 15
American writer
b. 1920
Windham left Atlanta in 1938 and headed to New York City to pursue a career as a writer. He befriended Tennessee Williams and collaborated with him on a play called *You Touched Me* (1945), based on a D. H. Lawrence story and starring their friend, Montgomery Clift. He published his novel *The Dog Star* in 1950 to excellent reviews; Thomas Mann considered it to be the finest American novel of the 1950s.

Duchess of Windsor (Wallis Warfield Simpson), p. 118
1896–1986
Duke of Windsor (Edward VIII), p. 118, 119
1894–1972
Wallis Simpson was a married woman, living in London, when she first met Prince Edward VIII in 1931. Prince Edward succeeded to the throne when his father died in 1936 but abdicated later that year via radio address: "I have found it impossible to carry the heavy burden of responsibility and discharge my duties as King as I would wish to do without the help and support of the woman I love."